7/2208081

# McCOY

## IN THE FRAME

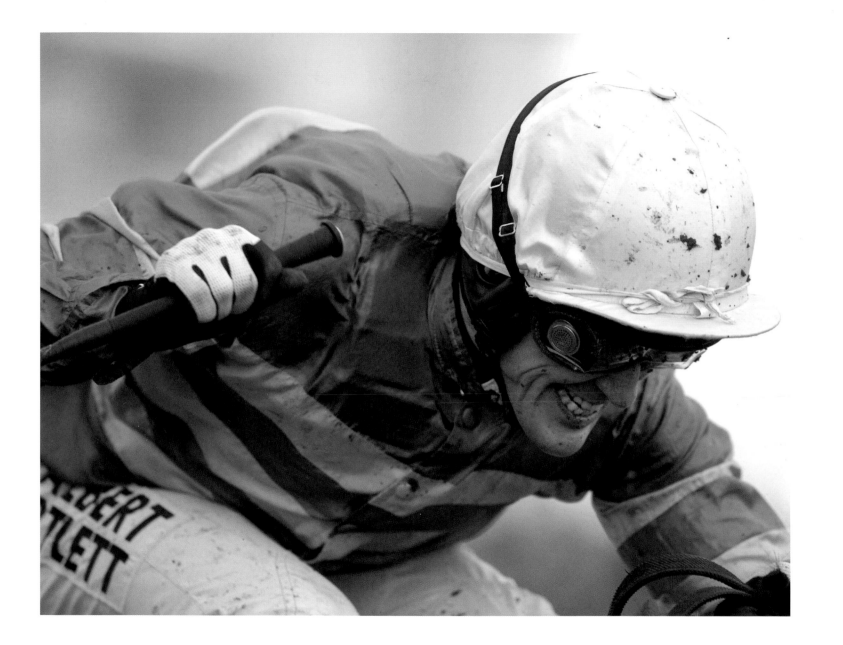

# McCOY
## IN THE FRAME

*Edward Whitaker*

**RACING POST**

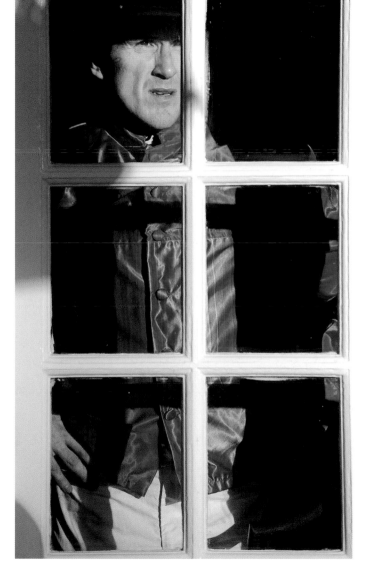

# *Contents*

*Frontispiece, left hand page*: THE 4,000TH WINNER

Towcester, 7 November 2013: AP drives Mountain Tunes home.
I was on the winning line shooting with a 550 mm F/4 Nikon lens
so I could focus on the final flight of hurdles, and go in close to
what was a driving finish.

*Frontispiece, right hand page*: IN THE WINDOW

Sandown Park, 6 March 2009: not 'In the Frame', but in the
window of the Sandown weighing room. This was just one month
after his 3,000th winner, and the angle of the sun lit him with
perfect shadow.

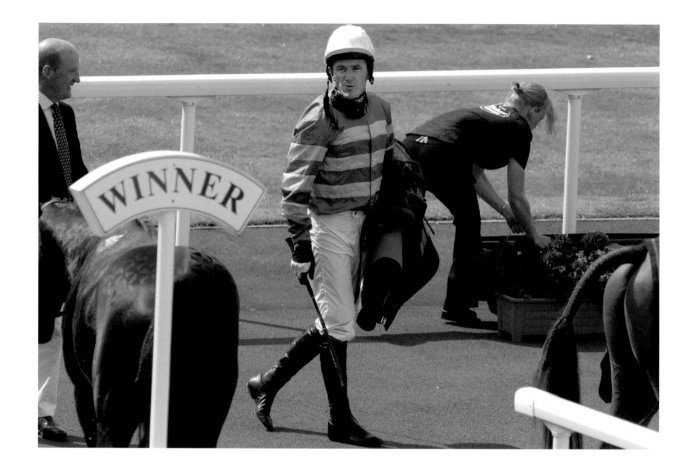

## WALKING BACK

Uttoxeter, 20 July 2004: AP in the green and gold silks of JP McManus – this was one of the first winners after he left the Martin Pipe stable to take the JP contract. I thought the word 'Winner' was going to be symbolic of what was to come.

# *Foreword*

This is the third of my 'In The Frame' books and looking back I suppose it is the one I have always wanted to do. Because what every sports photographer dreams of is to be posted around a truly iconic figure at the height of his powers.

Over the years AP has given me unbelievable access both in times of celebration and those of terrible agony. Much of this was made possible by the support of his long term PA Gee Bradburne who unfailingly supported my eagerness in taking his picture. I wanted to make this book a celebration of one of the most extraordinary careers in sporting history and one in which I was lucky enough to be in a position to record.

Quite early on in his career it was obvious that McCoy was putting us in the presence of something entirely different. The longer I travelled with him, the more I felt how lucky we were to have someone at the very top of his game, going not just to the great arenas like Cheltenham and Aintree, but out into the country to courses such as Ludlow, Exeter and Hereford.

He is truly special, receiving Honorary Doctorates, invested with an OBE by the Queen at Buckingham Palace and becoming the first ever racing figure to be voted BBC Sports Personality of the Year. But as these pages will show, the abiding attraction is not the fame but the

unceasing commitment to his craft. Of all the sporting professions, none matches the relentless, risk-filled treadmill of the jump jockey's deal. For what has made AP McCoy unique amongst other sportsmen of his era is that year after year, month after month, day after day, he has faced the challenge and looked for more.

We will never see his like again. These pages are tribute to that.

# SETTING THE PACE
# 1998–2002

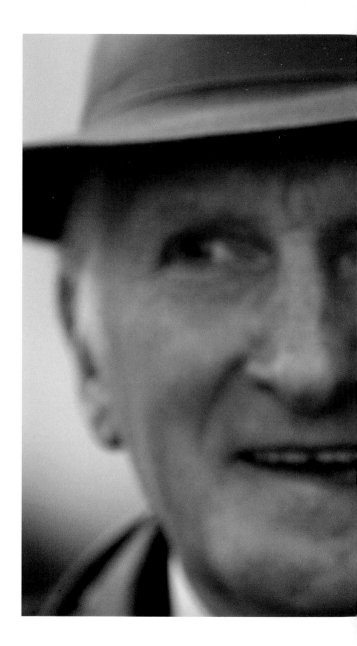

## THE ALL-CONQUERING PAIR

Chepstow, 10 November 2001: they were
both champions in every year they were
together, from 1997 to 2004. I like the way
McCoy is focused and engaged with me,
while Pipe's quicksilver mind is already
on something else.

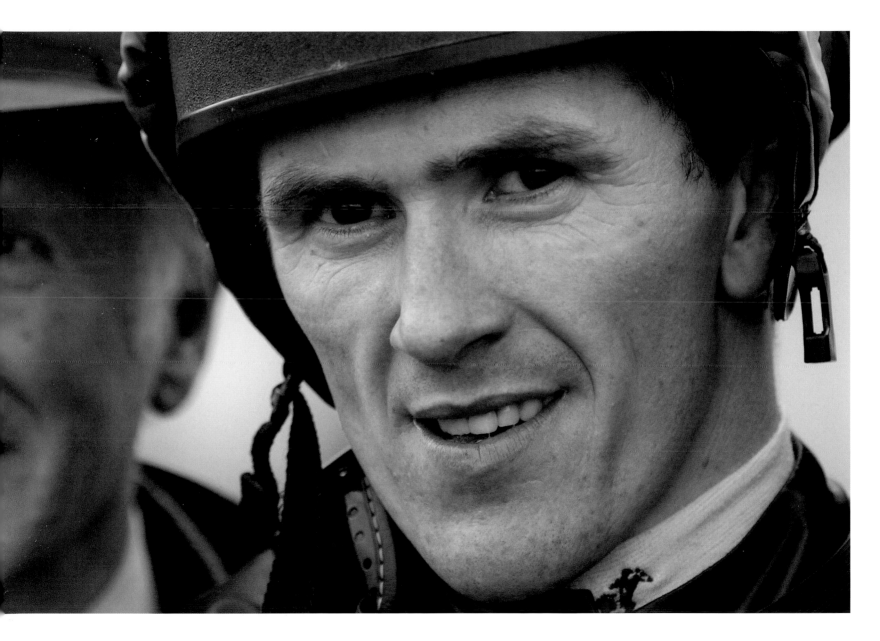

# SETTING THE PACE
## 1998-2002

When I first started photographing, jump jockey Peter Scudamore was the king. He was champion jockey seven times in a row, and his partnership with trainer Martin Pipe saw them tearing up the record books. By 1998 McCoy had been champion jockey three times already but he was setting an altogether different pace. There were at least 16 more championships to come!

While 'Scu' came from a traditional British jumping family, Tony (as we all called him then) came over from Ireland with no racing background. There were times in these early days when it was as if he had a point to prove. I had never met any jockey with quite such an obsession for winning. There were no limits to what he would do. He never, ever put up overweight – look at the face on the opposite page. And of course a super-obsessive jockey is just what Martin Pipe had to have. They were made for each other.

But for all Tony's success, outsiders took time to warm to him. Because while for him being second was always being a loser, to others it seemed close to bad sportsmanship. Look at the picture of him on Iznogoud coming back after finishing second in the 2002 Royal & SunAlliance Chase at Cheltenham. In those days people could not understand how much he cared. But I had begun to realise that to him victory was the only satisfaction – just look at the redemption in his face on page 29 after he answered his critics on Best Mate at Kempton.

Back then I had begun to realise that he was made of altogether different stuff. The pain in the fall (page 21) was never going to stop him, however much it hurt (page 22)! Maybe he still couldn't win the Grand National (pages 19 and 31), but there was no mistaking the pride at the fastest 100 winners (pages 25) and the ecstasy (page 32) at breaking Gordon Richards' 59-year-old record of 269 winners in a single season.

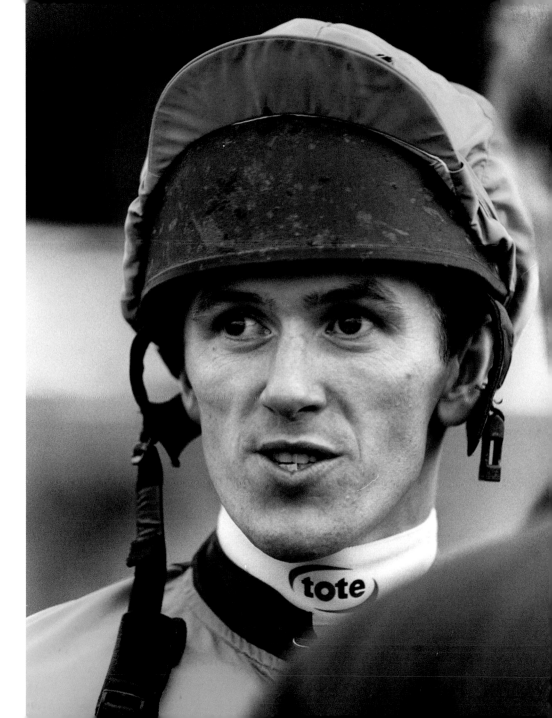

## BOILED DOWN TO THE MINIMUM

Cheltenham, 14 November 1999: McCoy
was set to carry ten stone on a horse called
Rodock, which had been heavily backed
in the feature hurdle race. Even by AP's
standards he had been through a drastic
regime, and I wanted to show the hollowed
eyes and the sunken cheeks. But the horse
won, so it had been worth it.

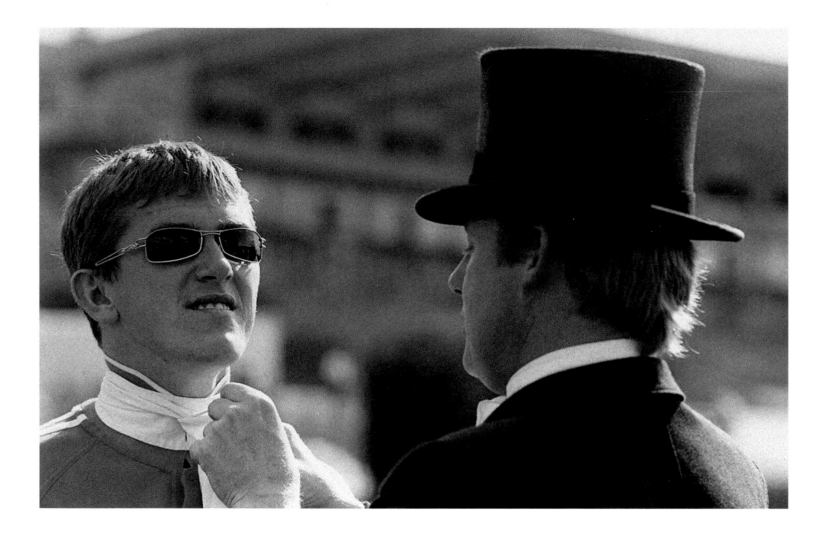

CHECKING THE STOCK

Sandown Park, 14 August 1998: AP has his hunting 'stock' tied by
Paul Webber, ready for a pageant at Sandown.

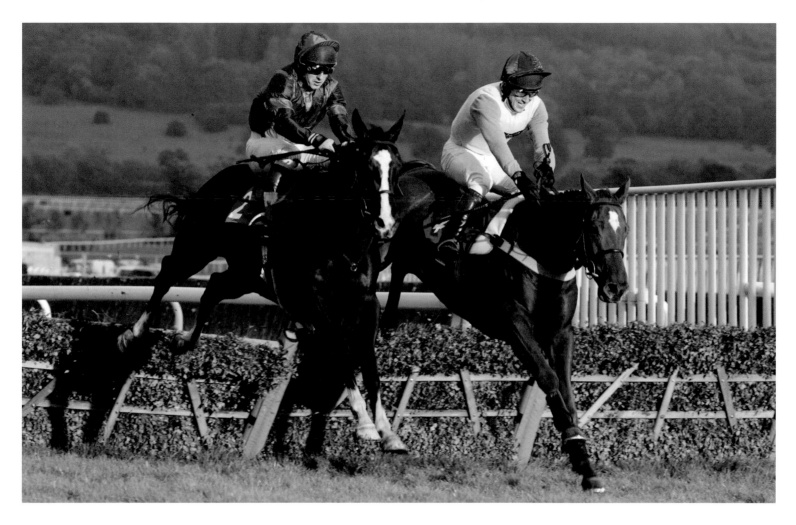

## McCOY IN DEFEAT

Cheltenham, 30 October 2001: Quazar (Tony Dobbin, left) jumps the final flight with Picture Palace (McCoy), in glorious autumn light at the first meeting of the season. AP's colours are the old-fashioned sweater, not the silks nearly always used today.

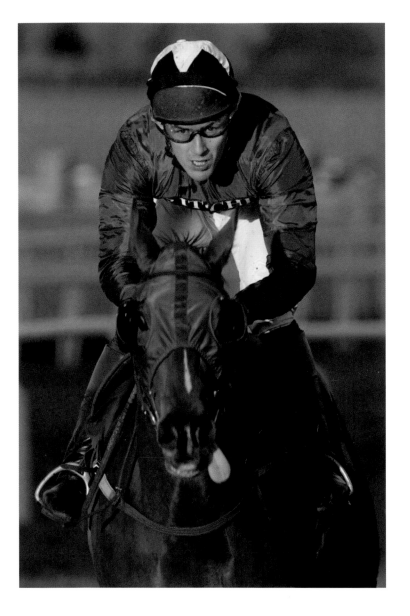

## SUNLIGHT AND SHADOW

Cheltenham, 31 October 2001: the aptly-named Shooting Light draws clear after the last fence. The race was off at 3.50 in the afternoon, and so the sun was very low.

*Opposite* JOCKEYS AT THE DRIVE

Aintree, 5 April 2002: from left, Noel Fehily, AP, David Dennis and Jason Maguire. Even in this shot, AP looks more controlled and committed than anyone else.

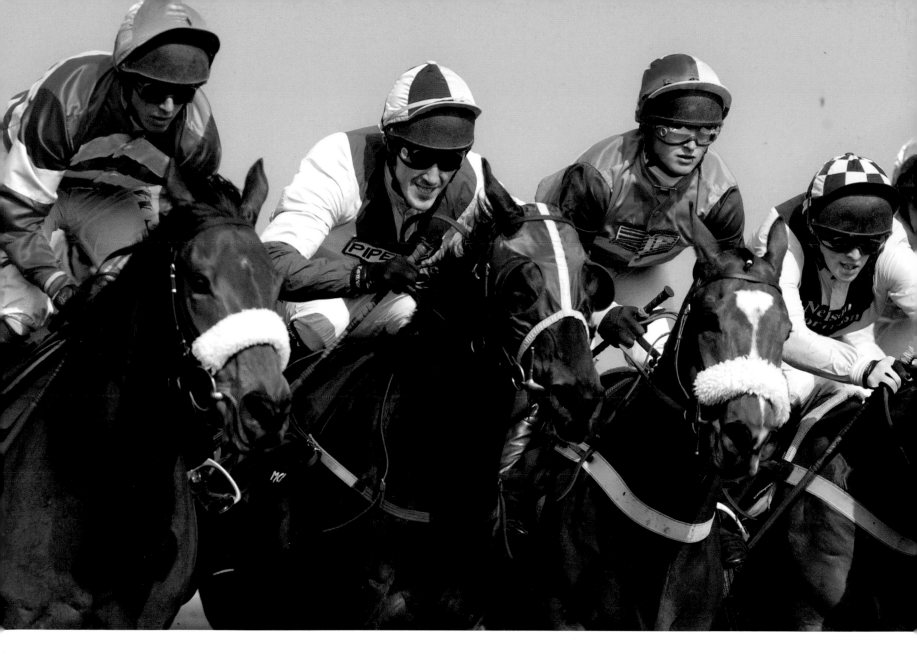

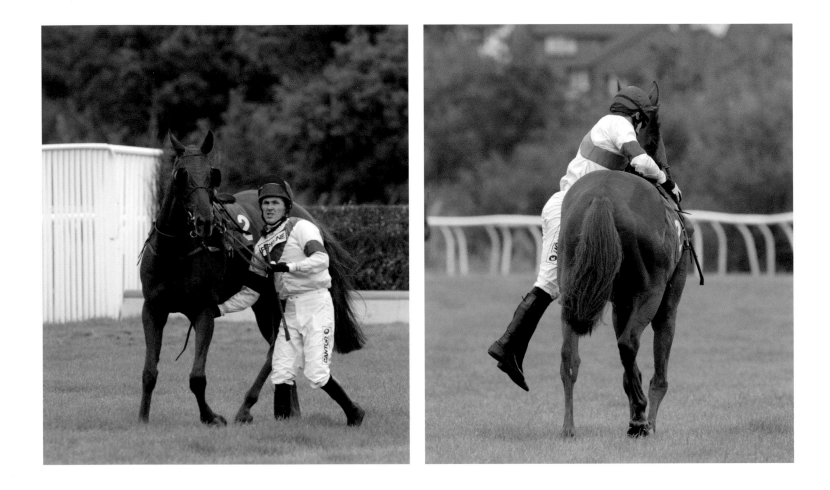

## THE CARING SIDE

Newton Abbot, 26 August 2002: AP dismounts and loosens the girth of a novice chaser called Versicium, who had gone lame after making the running until halfway.

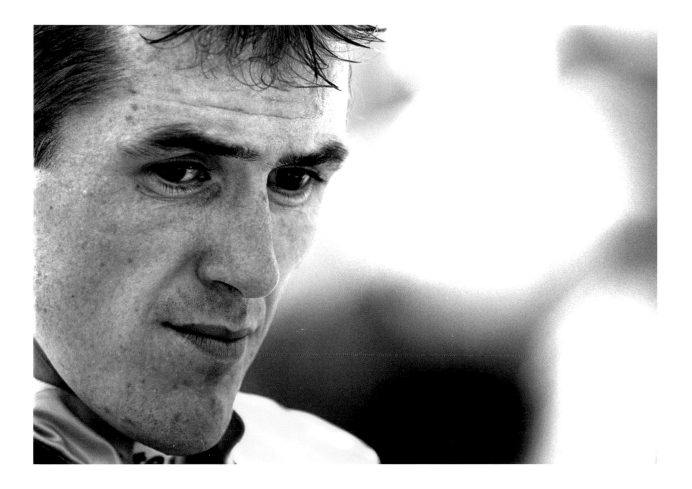

## FIVE TIMES A CHAMPION

Sandown Park, 29 April 2000: McCoy has just been crowned champion jockey for the fifth time. There were at least 14 further championships to come. I like the absolute lack of complacency in the face.

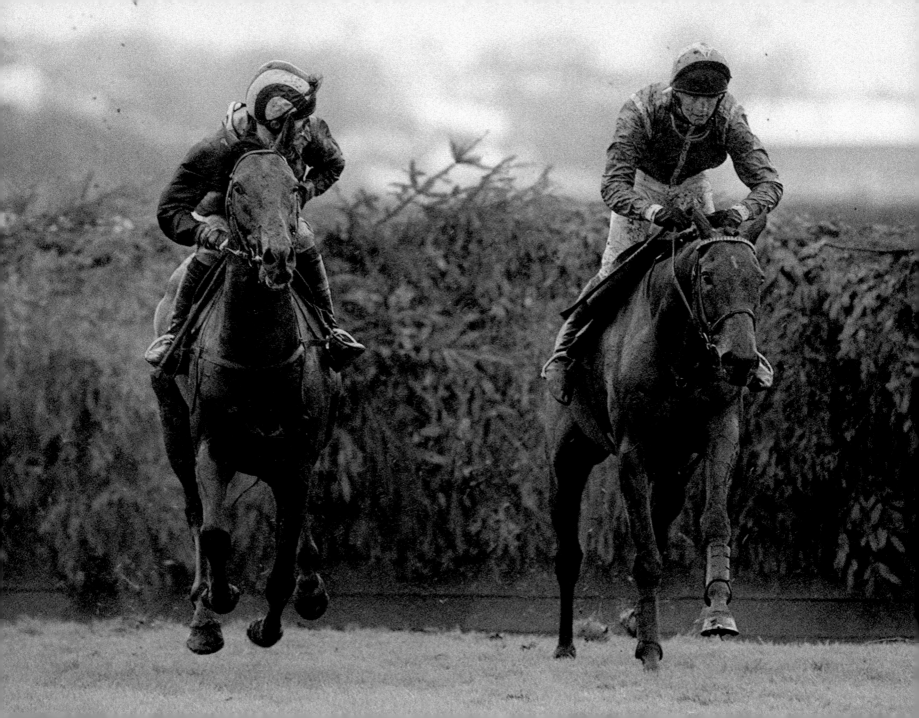

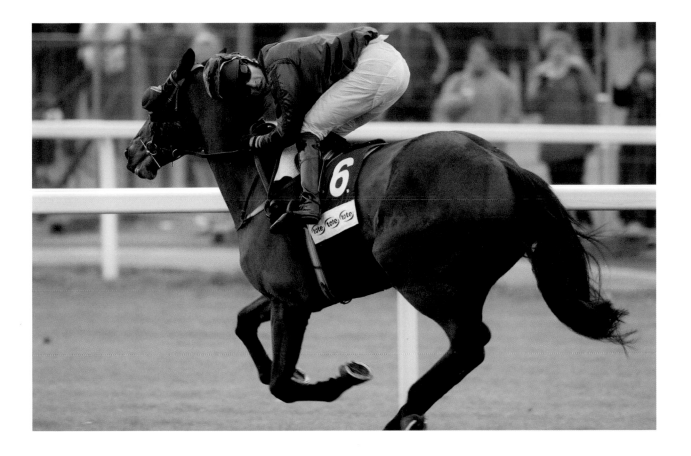

**_Left_ MUDDY SURVIVAL**

Aintree, 7 April 2001: AP on Blowing Wind (_left_) looks across at Ruby Walsh on Papillon as they land over Becher's Brook, on the second circuit of a rain-soaked and chaotic Grand National. Three fences earlier they had both been brought to a halt, but continued on to become the last two of only four horses who made it to the finish.

**BACKWARD GLANCE**

Chepstow, 10 November 2001: Majed comes home clear in the feature hurdle race, and AP looks round for non-existent dangers. It's not something you see him do often, but I like the suppleness of the movement.

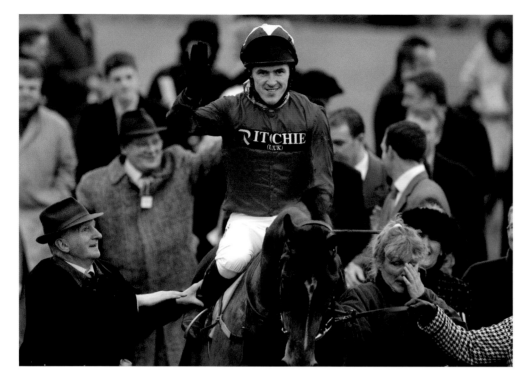

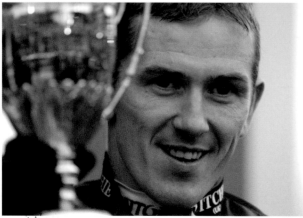

## SHOOTING LIGHT AGAIN

Cheltenham, 17 November 2001: this time (see page 14) winning the much bigger Thomas Pink Chase, one of the great races of the autumn. At this stage Pipe and McCoy seemed to be winning all the Saturday features, and I think the shots capture the joy in that.

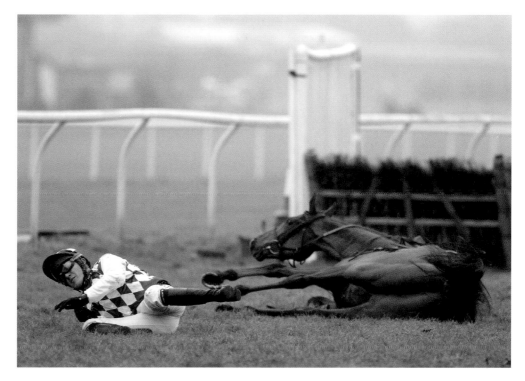

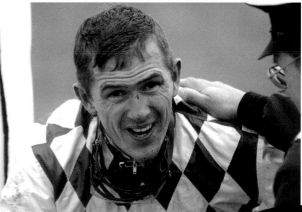

## A SECOND FALL OF THE DAY

Newbury, 9 January 2002: Bow Strada
crashes at the final flight; the bottom
picture shows the pain.

7/2208081

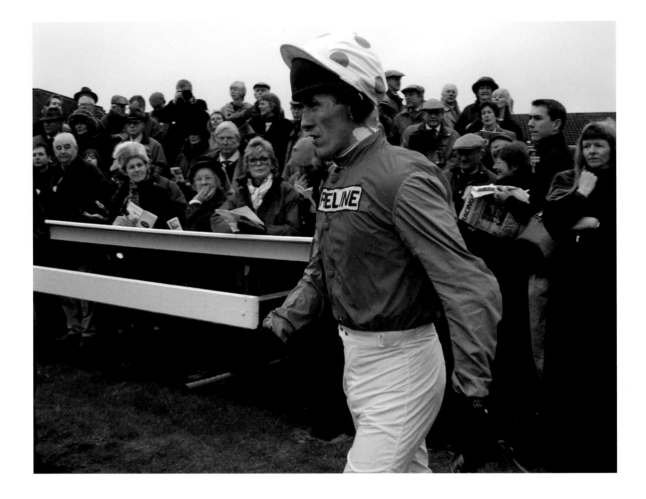

## THE DAY AFTER THE FALLS AT NEWBURY

Wincanton, 10 January 2002: when McCoy walked into the paddock for his first ride, the bandages behind the neck were clear to see, and so too was the gingerly walk. The woman to his left with the glasses was not the only one showing concern.

## MUDDY McCOY

Cheltenham, 26 January 2002: this is how it gets in midwinter. When you want to find someone truly mud-splattered, look no further than AP.

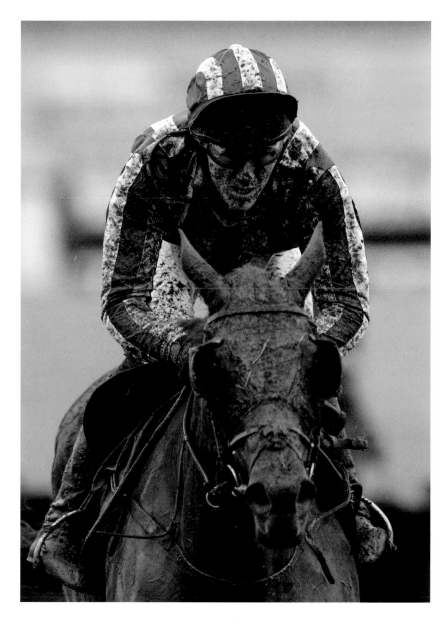

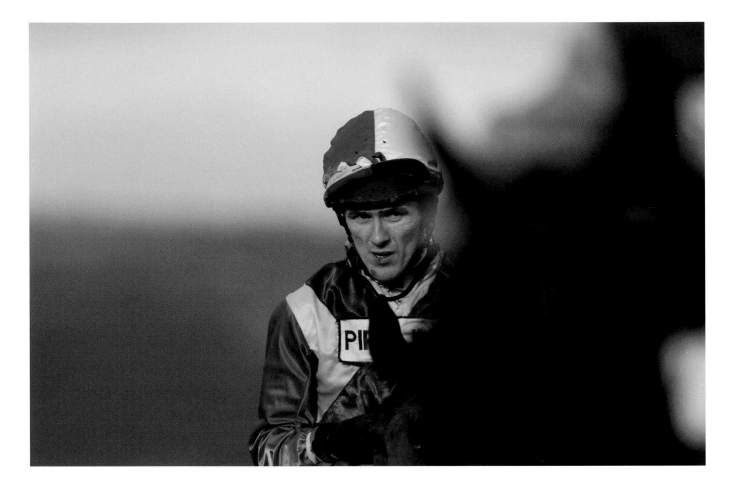

## THE DARK SIDE OF THE FESTIVAL

Cheltenham, 13 March 2002: novice chaser Iznogoud has just finished runner-up in the Royal and SunAlliance Chase, on the second day of the Cheltenham Festival meeting. McCoy is still without a winner. His biggest hope, Valiramix, had slipped up and died in the Champion Hurdle on the opening day. The media were getting on his back for being a sour loser. He was just hating it.

## THE JUTTING JAW

Plumpton, 17 September 2001: a horse called Present Bleu has just won over hurdles, landing Tony McCoy the fastest 100 wins by any jump jockey in a season.

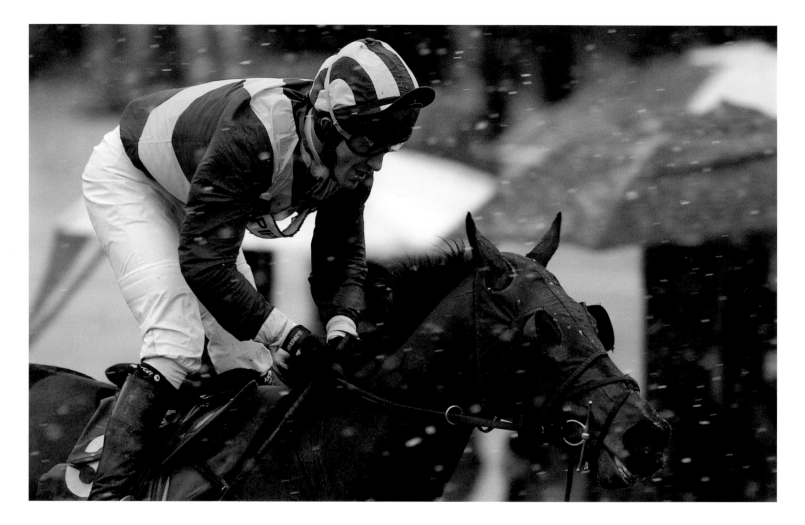

## SNOWFALLS AT LUDLOW

12 December 2002: this can be the coldest place in the world, but it is always lovely. McCoy drives through snow flurries on Peter's Two Fun in the novice handicap hurdle.

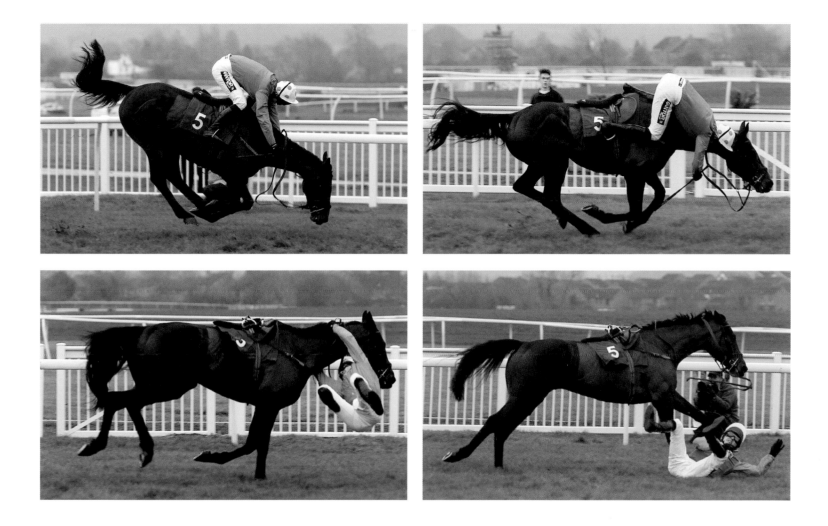

GRAVITY WILL NOT BE DENIED

Cheltenham, 14 December 2002: Golden Alpha
shifts McCoy at the second-last fence.

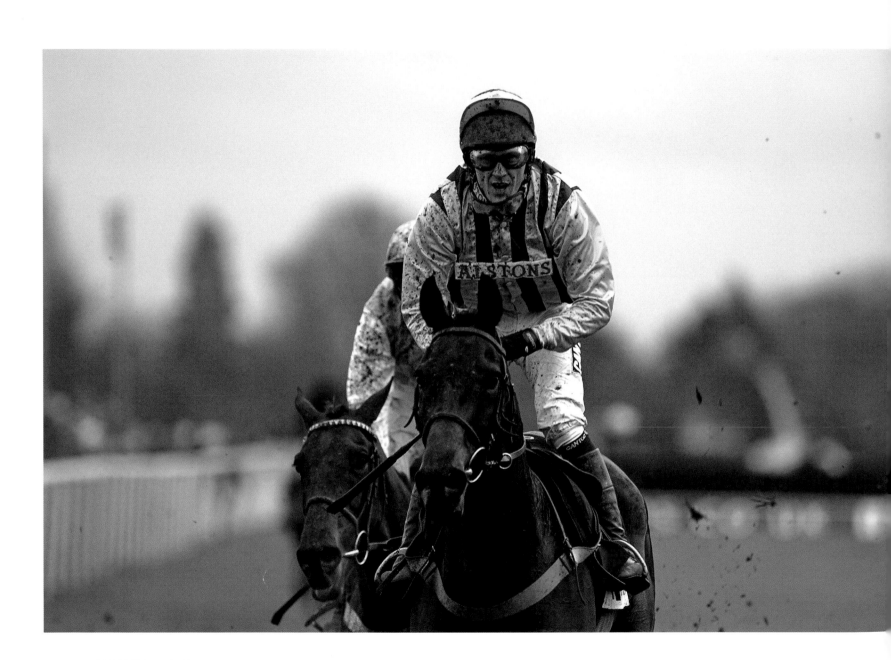

## REDEMPTION

Kempton Park, 26 December 2002: in 2001 McCoy felt he had been unfairly criticised when beaten on future triple Gold Cup winner Best Mate in the King George VI Chase on Boxing Day. Victory in 2002 felt good, and he showed it.

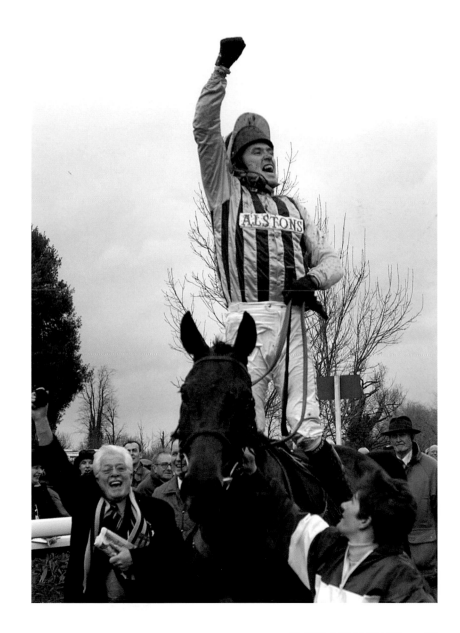

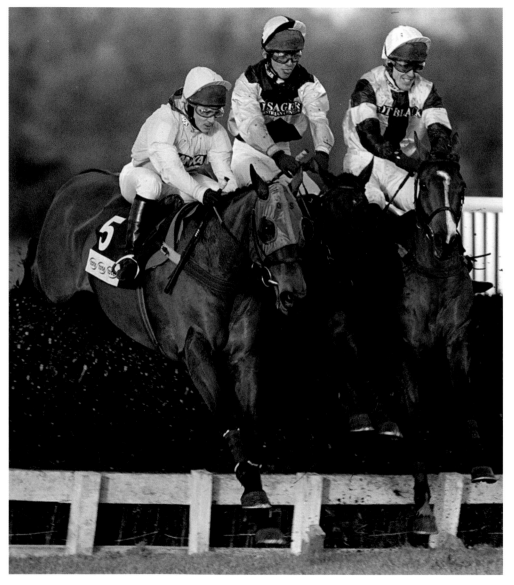

## IN TIGHT

Chepstow, 2 December 2000: McCoy relishes the battle at the first open ditch with BJ Crowley (*centre*) and Jimmy McCarthy (*left*).

## *Opposite* EYES RIGHT

Aintree, 8 April 2000: McCoy, on the favourite Dark Stranger, looks across at the start of the Grand National, but his bad luck in the race continues when they crash out at the third.

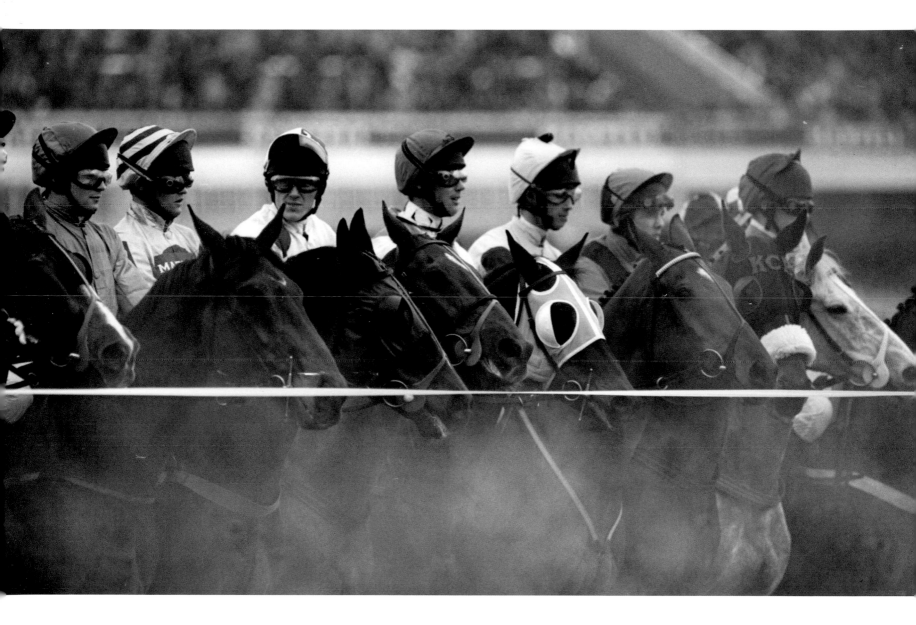

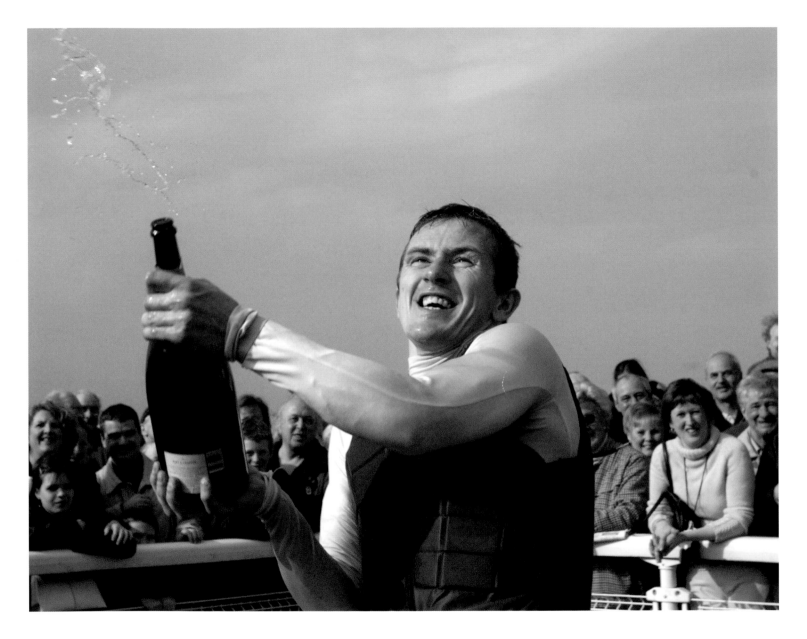

## THE MAGNIFICENT TWO

Sandown Park, 25 April 1999: with
Frankie Dettori before their match race
over one mile on the Flat. McCoy won
by a length and a half, and took £5,000
for charity.

## WHO'S THE GUVNOR?

Cheltenham, 22 February 1999:
McCoy may have become the champion,
but Richard Dunwoody had been the
master, and he the apprentice.

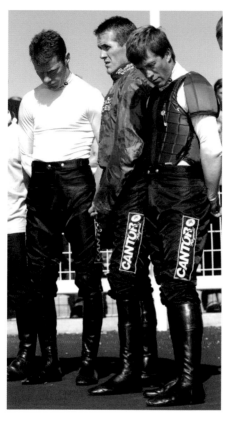

*Opposite* BREAKING LIMITS

Warwick, 2 April 2002: McCoy celebrates
beating Sir Gordon Richards' record of 269
winners in a season, after bringing Valfonic
home in a novice handicap hurdle.

*Above* JOCKEYS BOW THEIR HEADS

Hereford, 11 September 2002: one
year on from the 9/11 Twin Towers
disaster that killed 658 of 960 Cantor
Fitzgerald workers in the north tower,
Mick Fitzgerald (*left*), McCoy and Carl
Llewellyn wear black breeches in
honour of their sponsor.

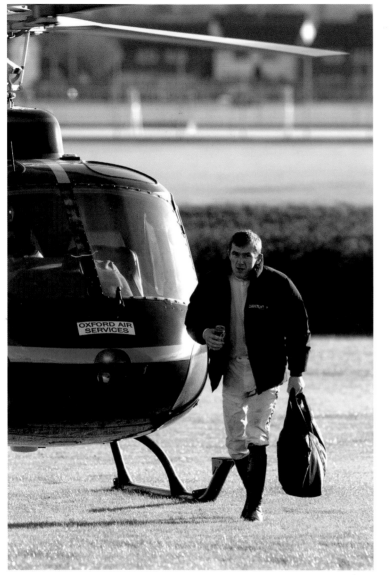

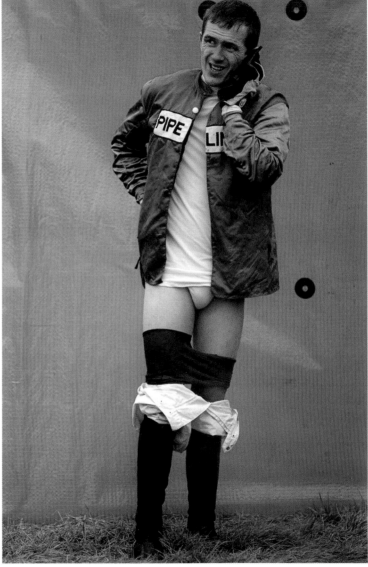

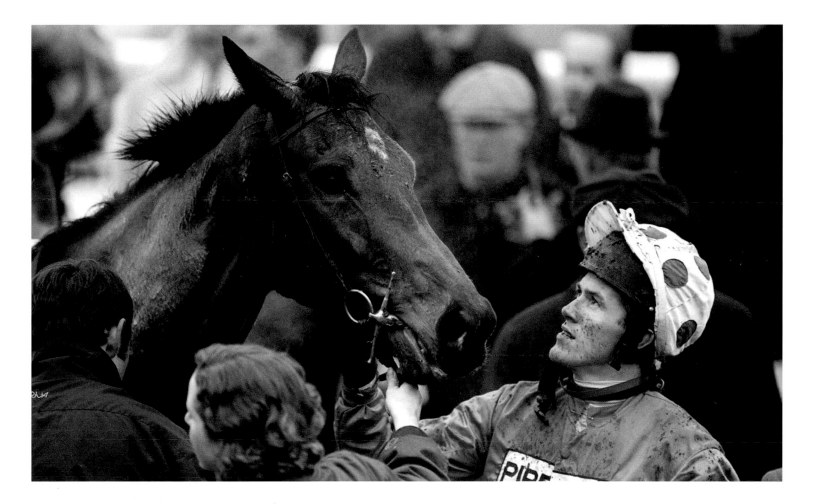

*Opposite* IN A HURRY

Hereford, 7 November 2002 (*left*) and
Kempton Park, 29 January 2001: a
helicopter dash to Hereford, and caught
with breeches down at Kempton.

YOUNG HOPEFULS

Cheltenham, 30 January 1999: a youthful McCoy looks up at the
six-year-old Cyfor Malta, who has just beaten that year's Gold Cup
winner See More Business. Cyfor was to be off for most of the next
two years, and never quite fulfilled his promise. Tony did.

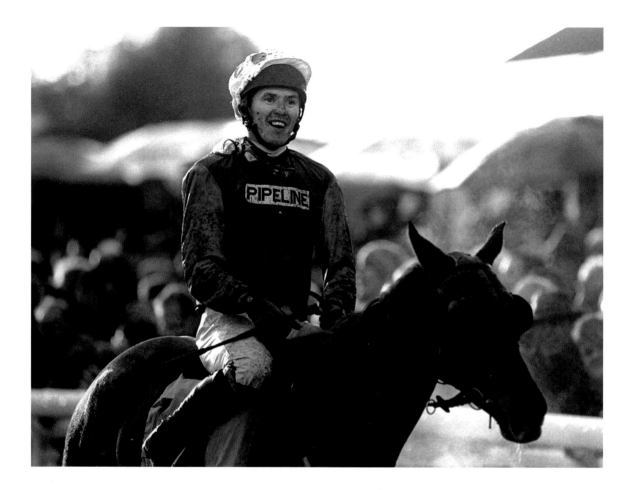

## THE RECURRING THEME

Cheltenham, 11 November 2000: McCoy and the mare Lady Cricket return after another Martin Pipe-trained winner of the Thomas Pink Chase. In those days McCoy did not often 'do' happiness.

*Opposite* NOT SO HAPPY RETURN

Cheltenham, 27 January 2001: Cyfor Malta finishes a distant third on his comeback two full years since his victory in the same race (page 35). If anything, owner David Johnson looks even glummer than Martin Pipe and AP.

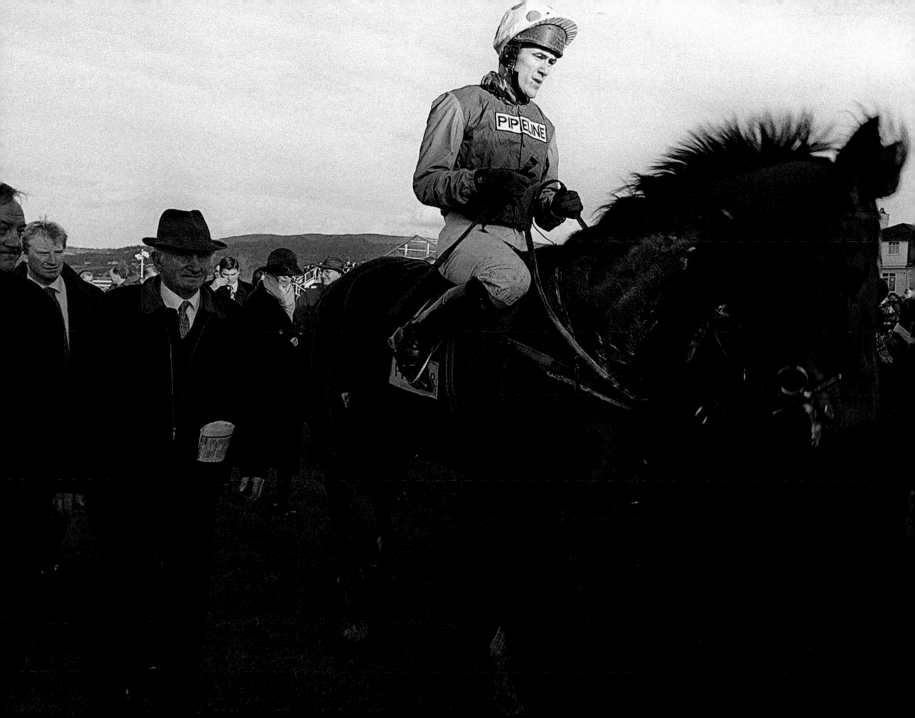

# EVERY QUESTION ANSWERED
# 2003–2007

# EVERY QUESTION ANSWERED
## 2003–2007

Breaking Sir Gordon Richards' record was a massive deal at the time. Winning jockeys' championships had become almost too easy but breaking these records added a whole new dimension to the McCoy ambitions. The Richards record had been deemed impossible. The years ahead had many more 'impossibles' to crack.

By now AP wasn't shy about the trappings of success. He liked his fast cars (page 52). He had a fabulous house outside Lambourn and was proud of the ever expanding row of Lesters on the mantelpiece (page 50). His wife to be, Chanelle Burke (page 50), was already part of his life. He had all the mod cons a 21st century bachelor could want and had the good sense to have the super efficient Gee Bradburne to organise his ever expanding diary.

Amazingly one of his most frequent house guests was Ruby Walsh, his greatest rival (pages 49 and 67). But then the great tradition of jump jockeys is that the shared awareness of pain brings them together. Look at Mick Fitzgerald's understanding at the McCoy broken nose (page 69), and the difference between the battered McCoy face in the mirror (page 54), and the jovial 'Irish Jockeys' Choir' (page 69).

AP McCoy was now becoming a legend in his own right, meeting the Queen (page 47), and sharing a joke with 'Legend of Legends' Lester Piggott (page 73). Life was settling down and his role as number one jockey to JP McManus (page 65), must have made some things easier even if McCoy himself only used it to drive himself ever on.

His could never be 'an easy life' but the confident figure on the physio bench (page 62), shows that it's the life he has chosen and the gladiatorial triumph on the opposite page shows you the adrenalin addiction that powers it all. Other jockeys, old and new, warmed themselves on his success. Jonjo O'Neill may have become his employer but he was also one of his greatest admirers. As for champion conditional rider Tom O'Brien, that look is nothing short of hero worship (page 75).

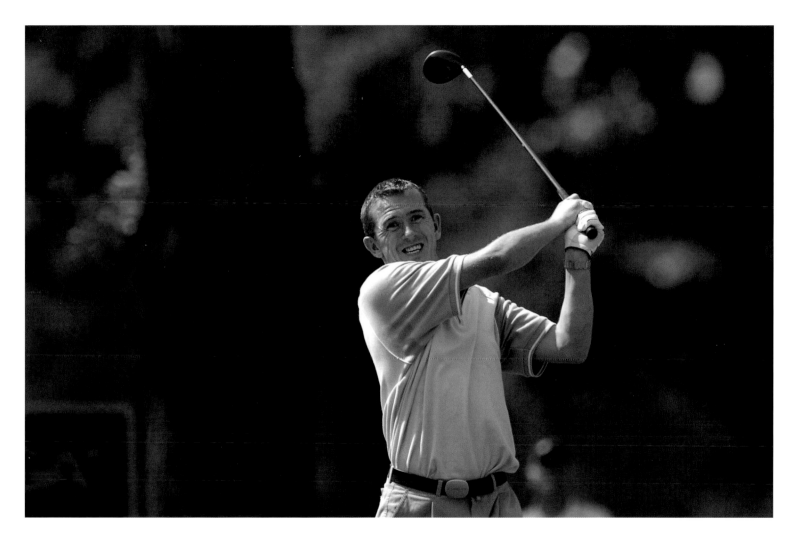

SPORT IS SERIOUS

The Belfry, 6 August 2003: McCoy at the first tee in the inaugural 'AP McCoy and Mick Fitzgerald Challenge Trophy Charity Golf Day'. You can't smooth the competitive edges off the face.

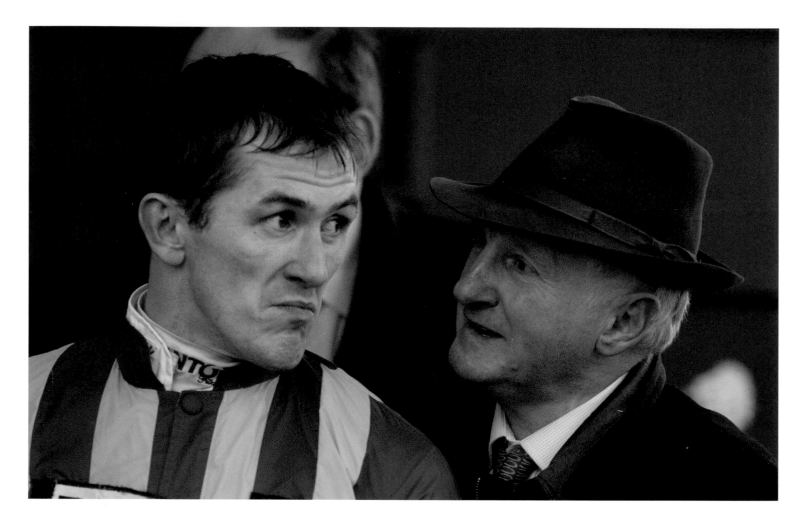

## PERFECTIONISTS ARE NEVER CONTENT

Ascot, 15 February 2003: McCoy and Pipe have just had a treble at Ascot, but you wouldn't think it.

## *Opposite* MOB-HANDED

Taunton, 16 January 2003: McCoy (*right*) is but one of ten jockeys riding for Martin Pipe (*left*) in one race. The stable duly filled first, second and fourth places. McCoy was only fifth.

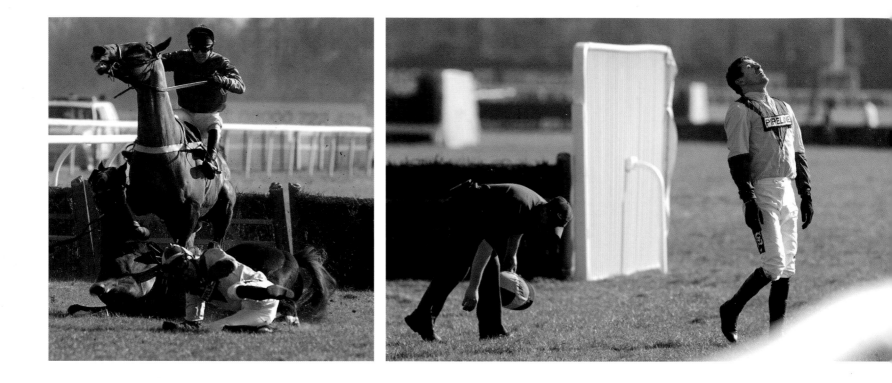

OUCH!

Kempton Park, 21 February 2003: McCoy
is buried by Neutron at the second hurdle,
and it hurts.

*Opposite* IN COMMAND

Ascot, 15 February 2003: AP and Shemdani
lead the field as part of the McCoy/Pipe
treble at Ascot (see page 42).

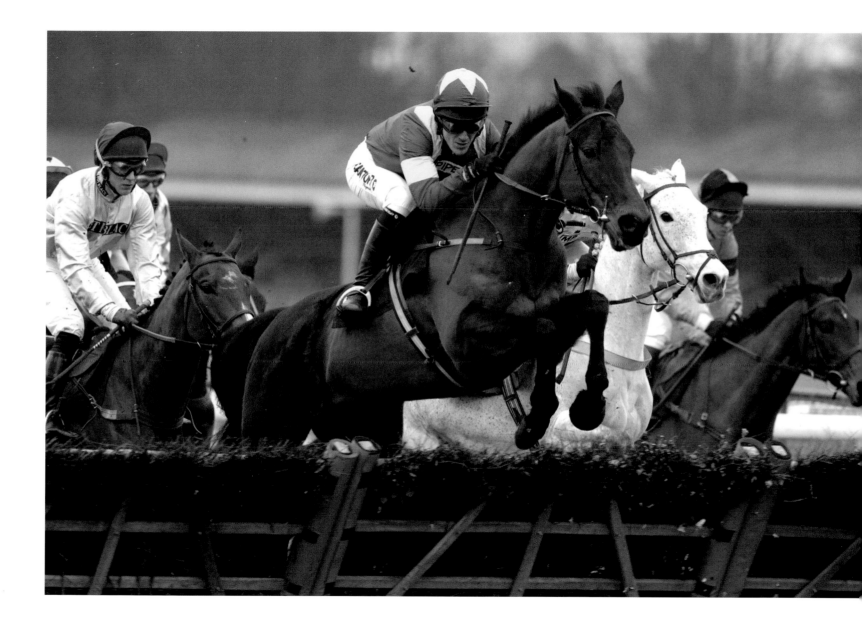

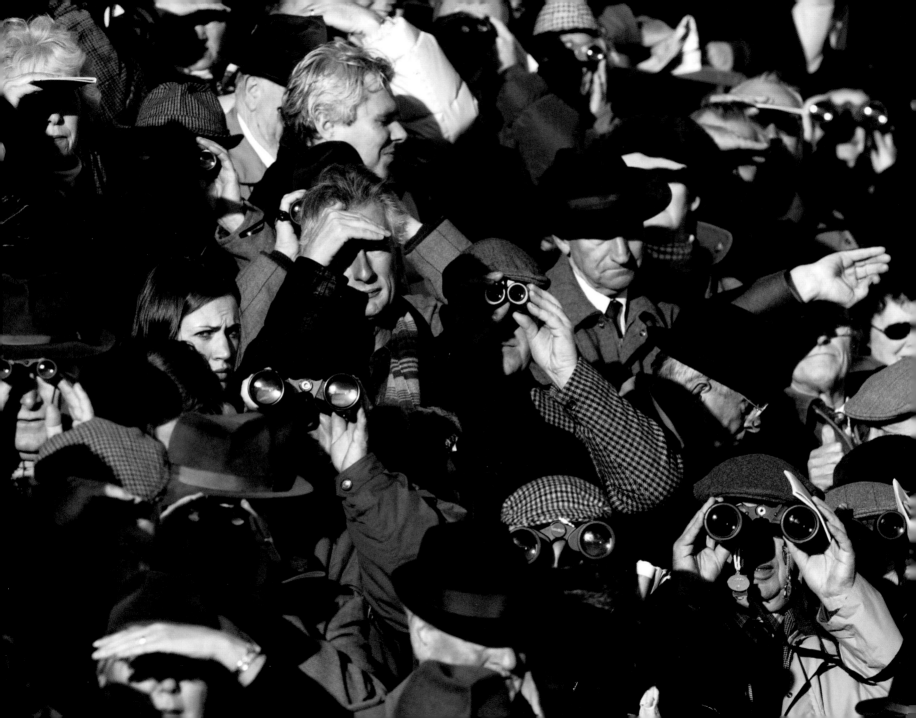

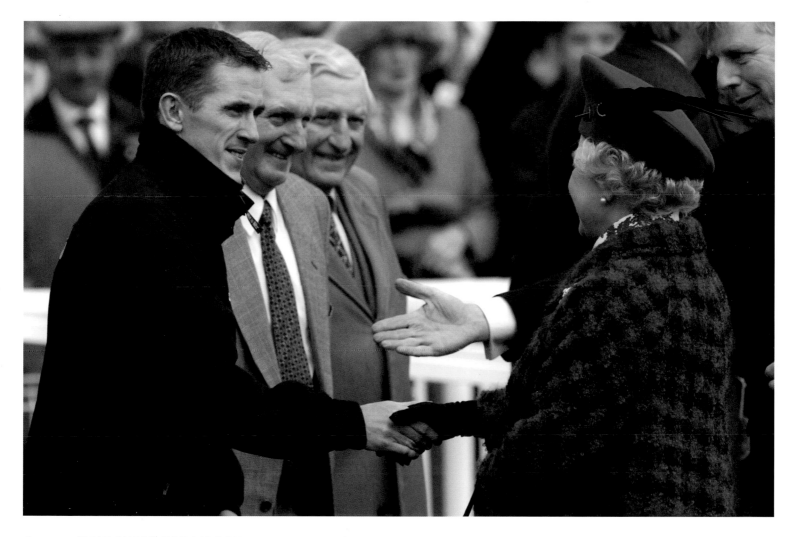

*Opposite* SEARCHING FOR MCCOY

Taunton, 16 January 2003: racegoers watching the ten Martin Pipe runners in one race (see page 43).

THE QUEEN MEETS RACING ROYALTY

Cheltenham, 13 March 2003: one year after the death of her mother, the Queen visited the Cheltenham Festival. Chief Executive Edward Gillespie (right) introduces Tony McCoy, Martin Pipe and Paddy Mullins.

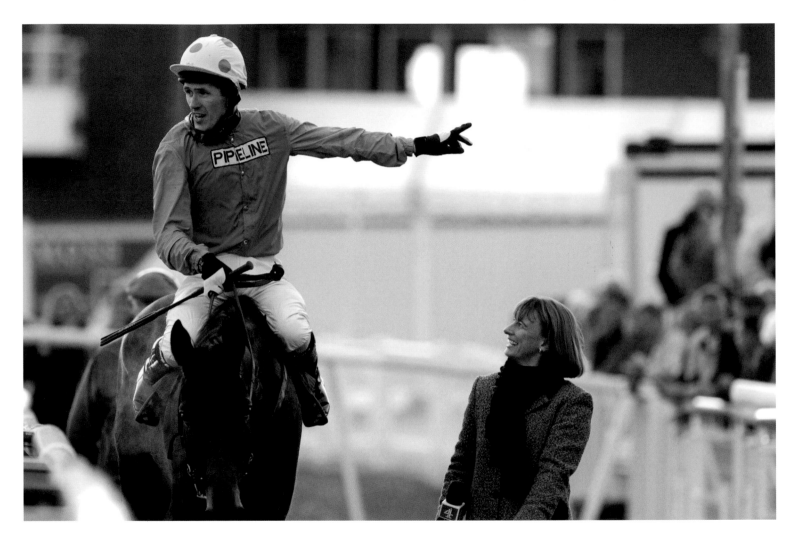

## IT WAS THAT EASY

Cheltenham, 15 November 2003: television presenter Lesley Graham looks on as McCoy tells
how he and Therealbandit have just sauntered home in the big hurdle race by seven lengths.

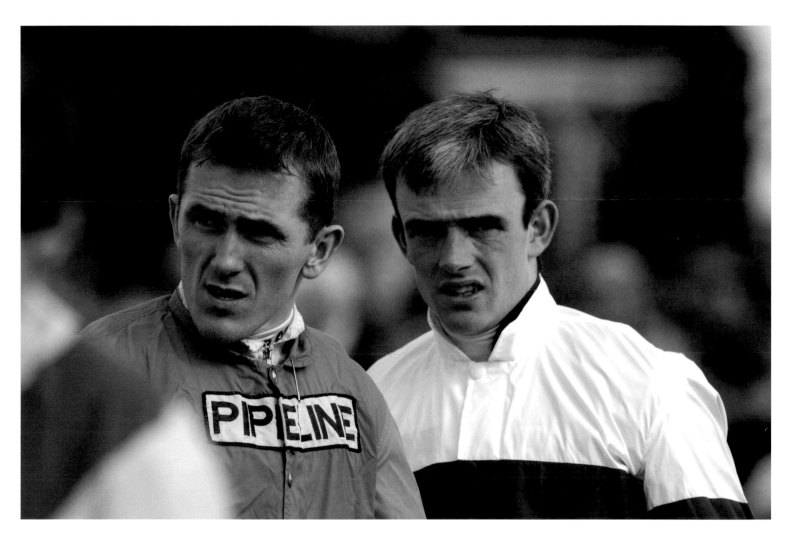

GOOD FRIENDS BUT TOUGH RIVALS

Cheltenham, 13 March 2003: Tony McCoy and Ruby Walsh had both
become champions, but this shot shows the harshness of their existence.

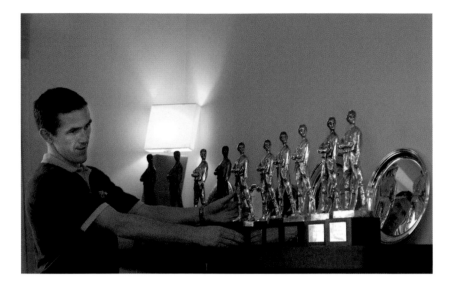

## AT HOME

Kingston Lisle, 18 January 2004:
*Left*: McCoy places his 10th Lester on
the mantelpiece the day after receiving
it in London. *Below left:* With wife-to-be
Chanelle and old friend T.J. Gormley.
*Below right and opposite*: Relaxing at home.
I had been photographing him for eight
years, and he was now at ease with me.

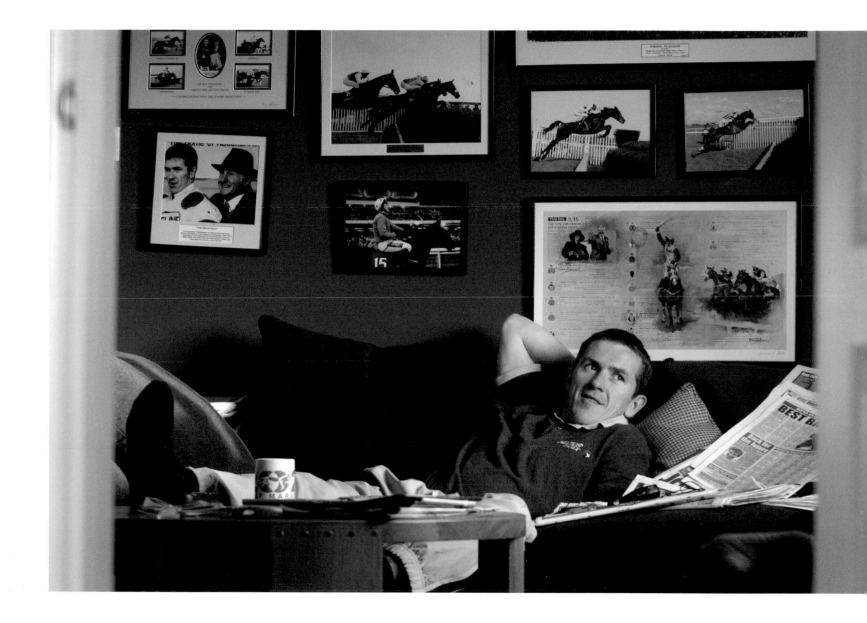

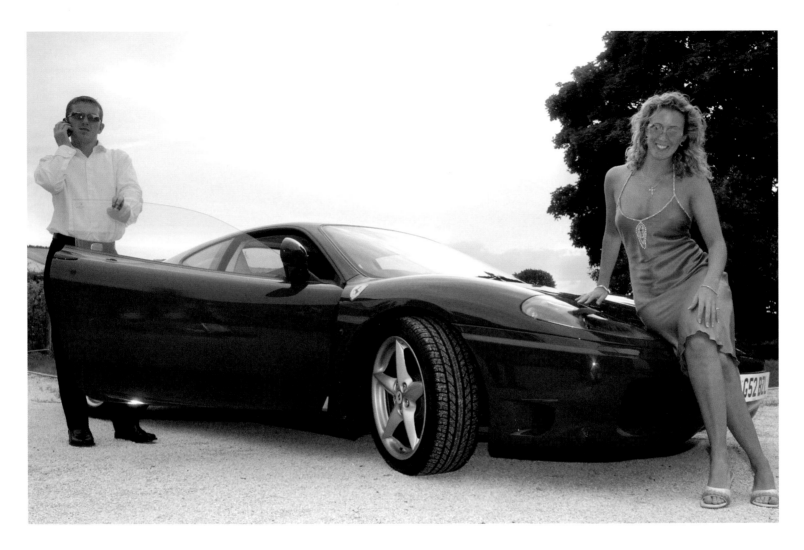

## UNCONVINCING BLING

Kingston Lisle, 19 July 2003: AP and Chanelle
pose with a loaned Ferrari 360 Moderna.

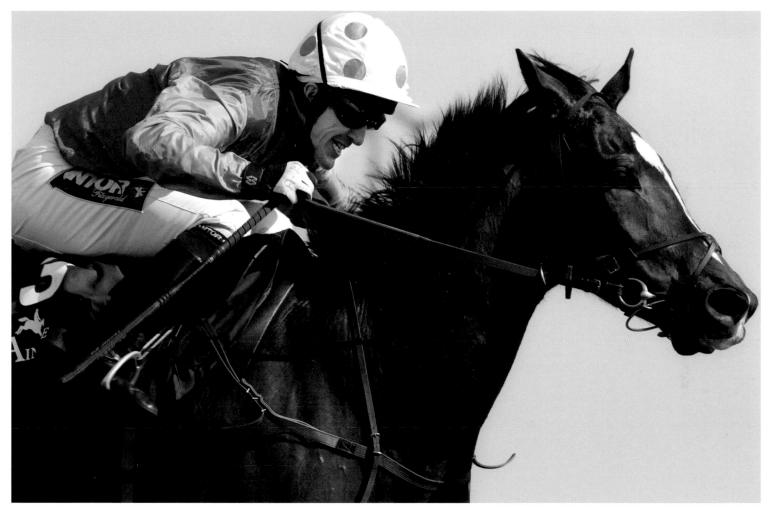

## ALL TO NO AVAIL

Aintree, 2 April 2004: AP and Contraband lead at the last hurdle, but are beaten a neck at the finish on the first day of the Grand National meeting. The shot shows how much kit is involved with horse and rider: cross nose-band, ring bit, breast girth and, for AP, goggles, gloves and whip. And that overwhelming will to win.

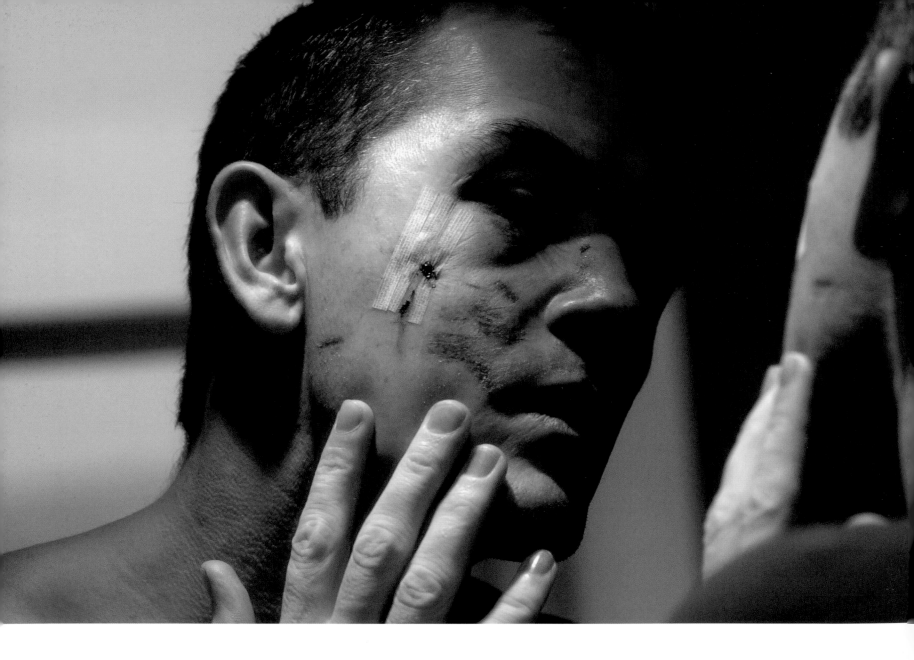

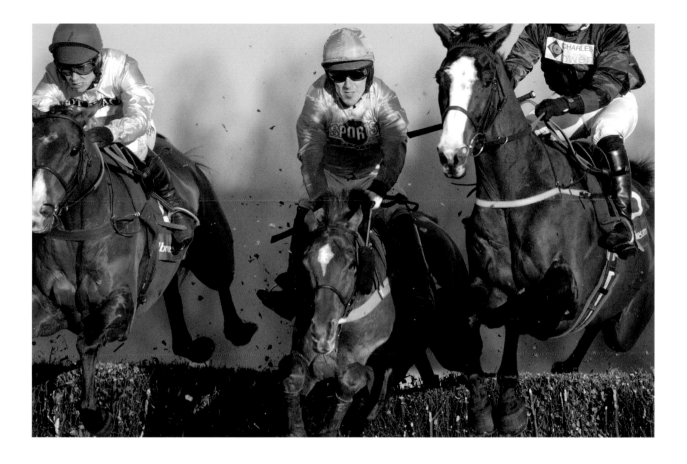

**Opposite** MIRROR, MIRROR, ON THE WALL

At home, 18 February 2004: McCoy had been smacked in the face in a fall at Plumpton the day before. Using the mirror and the shadow helps to enhance the pain in the photo.

THE LOW DIVE

Sandown Park, 8 January 2005: AP does not get very high at Sandown next to long-time championship runner-up Richard Johnson.

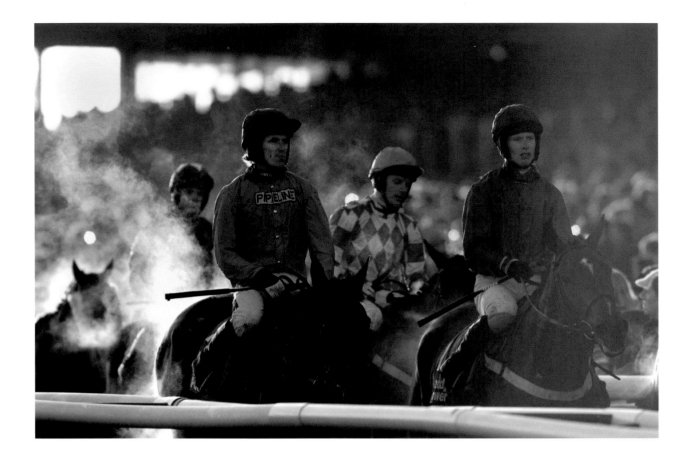

## THOUGHTS IN THE STEAM

Cheltenham 12 November 2005: AP, now under contract to JP McManus, rides back on the well-beaten Martin Pipe second-string Therealbandit, after the favourite Our Vic had given Pipe another Paddy Power Gold Cup success with new jockey Timmy Murphy in the saddle.

## VICTORY SMILE

Cheltenham, 10 November 2006: winning chaser Rubberdubber amuses McCoy with an impromptu thanks in the unsaddling enclosure.

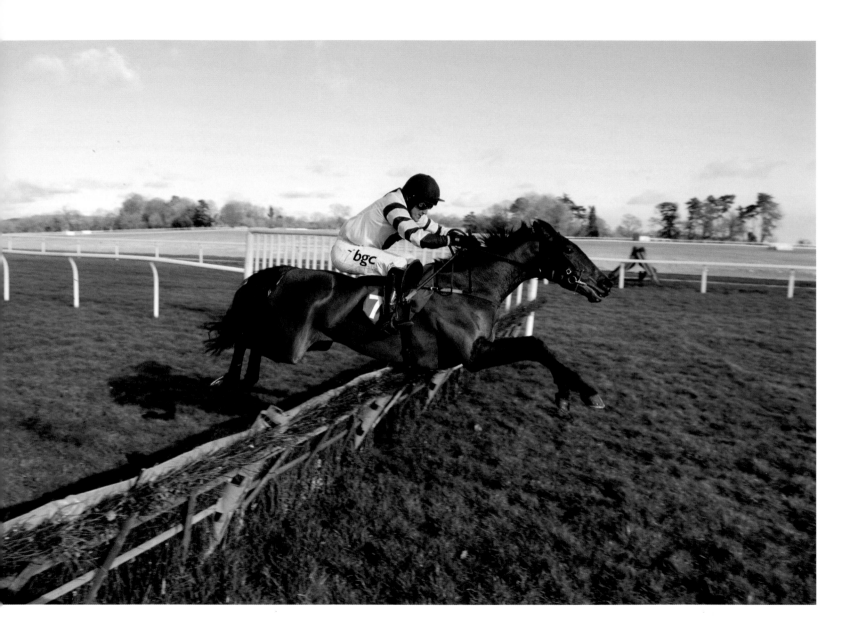

## UNHAPPY HENNESSY

Newbury, 1 December 2007: McCoy and Irish raider Snowy Morning started favourite for the Hennessy Gold Cup, but the ninth fence took them out – and it hurt.

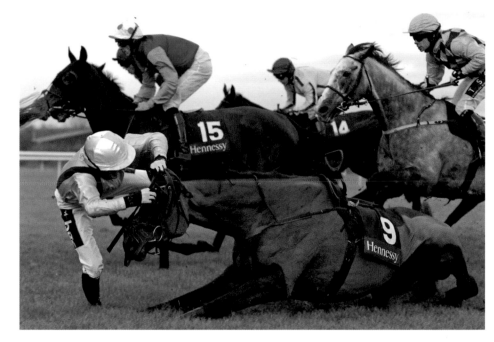

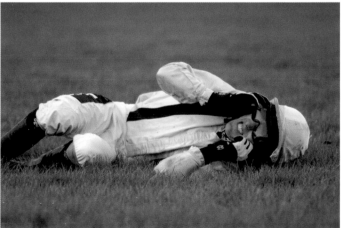

*Opposite* IN FULL FLIGHT

Chepstow, 2 February 2007: four-year-old filly Gaspara has daylight behind her at the second-last.

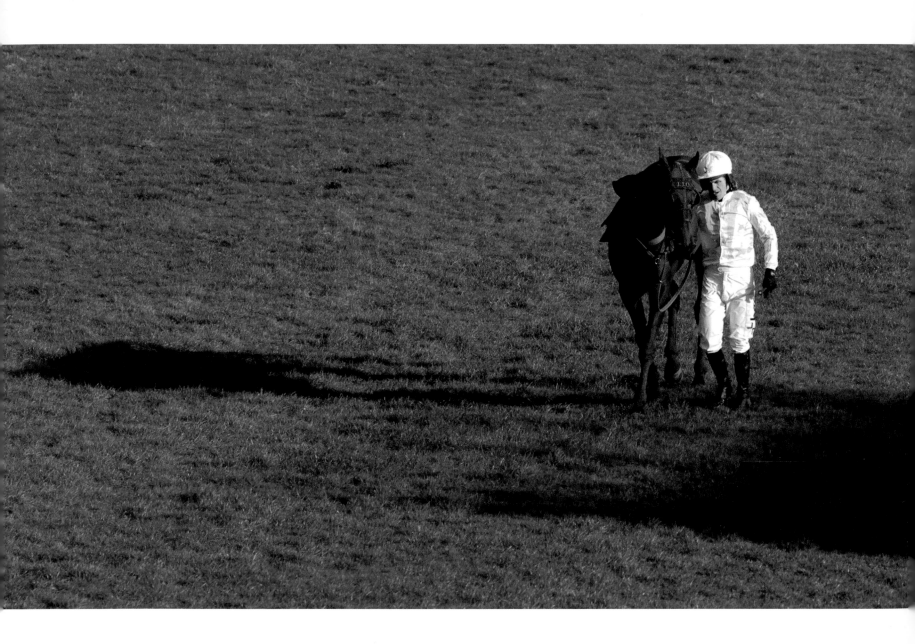

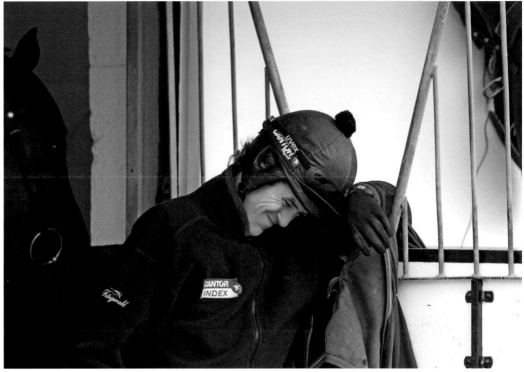

## ON FOOT

Ludlow, 1 March 2007: McCoy leads the hurdler Basic Fact after pulling up in the novice hurdle. The picture works because it is clean: it is just green grass, shadows and him walking back, with the light silks accentuated by the dark background and the oddity of him being on foot.

*Above* NO PAIN, NO GAIN

Upper Lambourn, 27 September 2006: McCoy rides out for the first time after eight weeks on the sidelines with a broken wrist.

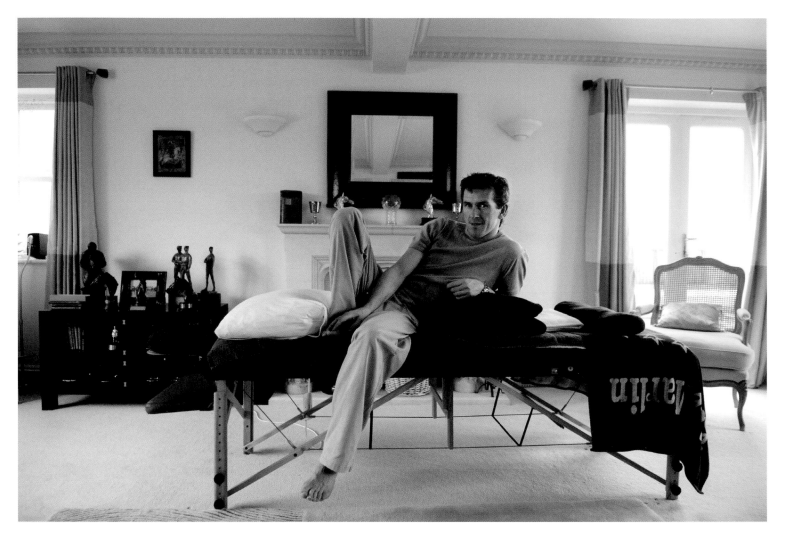

## CALM BEFORE THE STORM

Kingston Lisle, 31 March 2006: at home on the massage table a week before the
Grand National. Even when so relaxed, his expression has that McCoy focus.

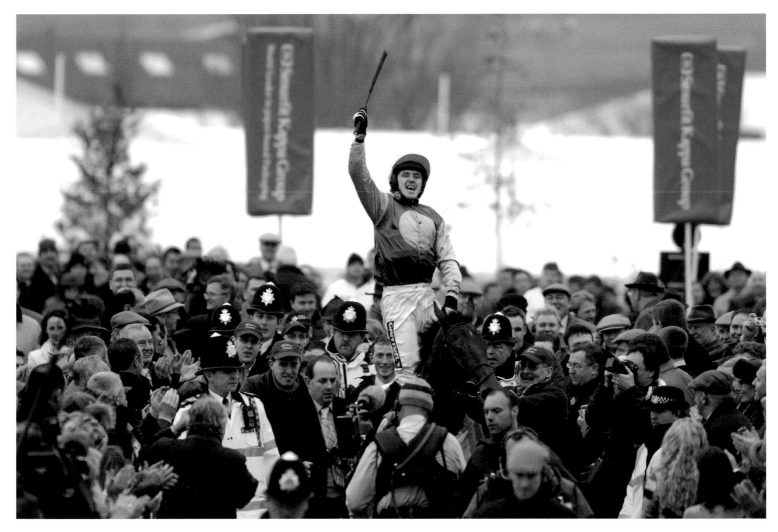

## THE GLADIATOR

Cheltenham, 14 March 2006: returning on Brave Inca after winning the Champion Hurdle.
There is a sort of gladiatorial power in the victory salute: a figure set up above the rest.

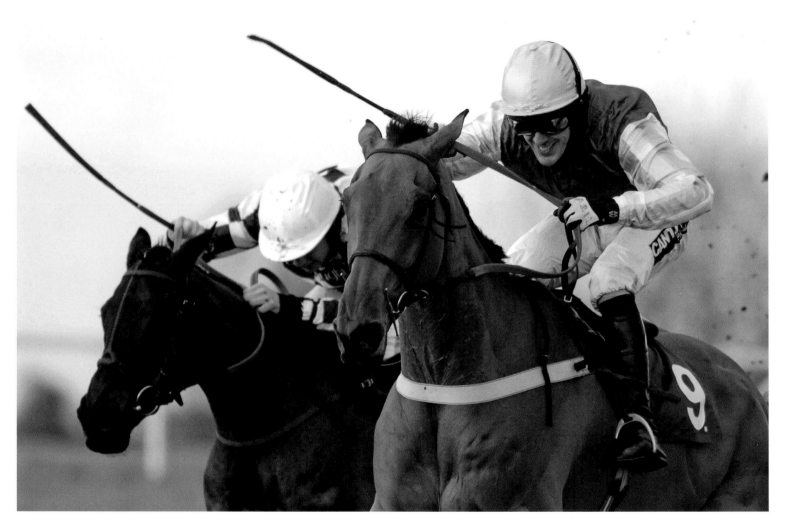

## WHIPS UP

Wincanton, 4 January 2005: although McCoy finished second in this race (on a novice hurdler called Hobbs Hill), I liked the symmetry of the whips – the other jockey was Christian Williams on Geeveem. For once McCoy has got his reins in a muddle, and so at first glance his whip seems to be about three feet long.

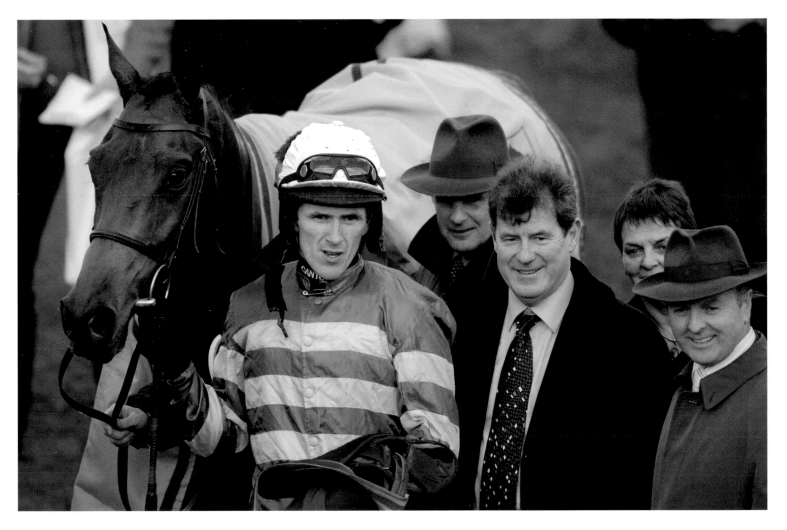

## THE NEW TEAM

Cheltenham, 13 November 2005: Lingo has just won the Greatwood Hurdle for JP McManus (*centre*), who stands alongside his racing manager Frank Berry, and principal trainer Jonjo O'Neill (*right*).

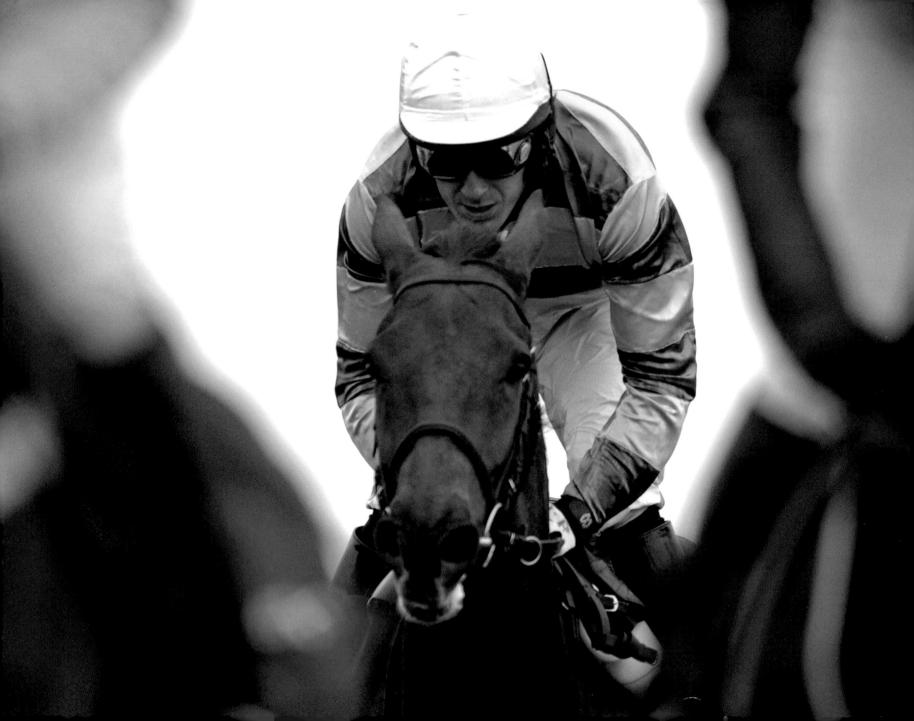

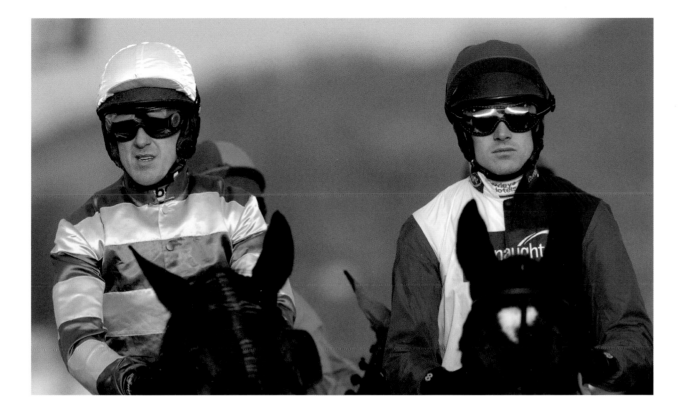

*Opposite* CONTINENTAL ELEGANCE

Aintree, 6 April 2006: McCoy on the
French-trained L'Ami, wearing the French
version of the McManus colours. I love the
elegant shape of this picture.

GOGGLES DOWN

Cheltenham, 9 December 2006:
Walsh and McCoy with their game faces
on – the leaders of the pack.

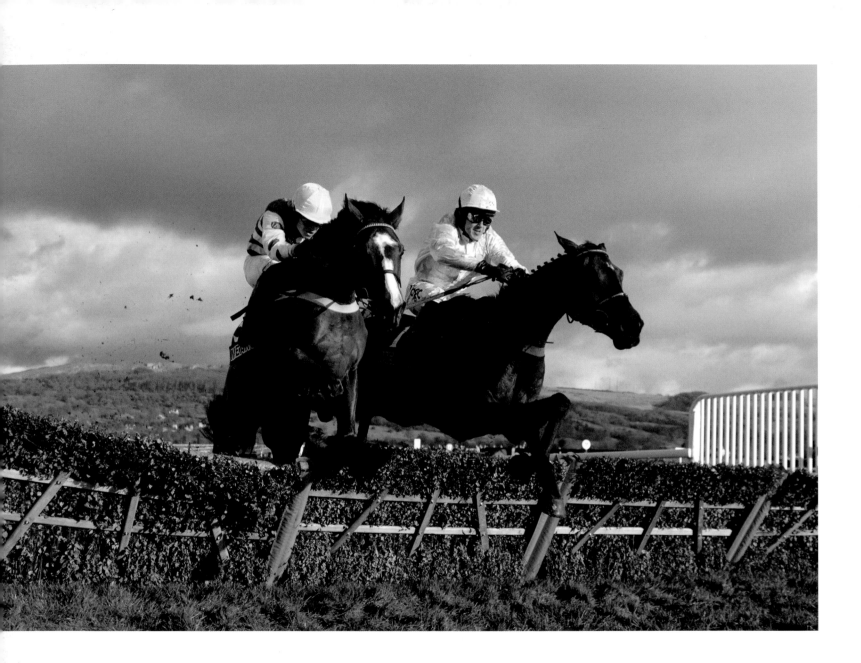

*Right* PUT ON THE SPOT

Mick Fitzgerald as interviewer and fellow singer (*below*). The interview was at Kempton on 27 February 2004 – Fitzgerald was to have four more years as a jockey, but was guesting for Channel 4. He would have known what a broken nose like McCoy's felt like.

*Below right:* The Irish jockeys' choir assembled at the Blowing Stone pub in Kingston Lisle in January 2003, for a charity rendition of 'The Fields of Athenry', with Mick Foster on accordion and Tony Allen on guitar. Singers from left: John Kavanagh, Adrian Maguire, Seamus Durack, AP, Mick Fitzgerald, Jimmy McCarthy, Timmy Murphy and Eddie Ahern.

*Opposite* RISING TOGETHER

Cheltenham, 9 December 2006: AP on Black Jack Ketchum (*right*) jumps the final flight with Blazing Bailey (Choc Thornton) before winning the Relkeel Hurdle.

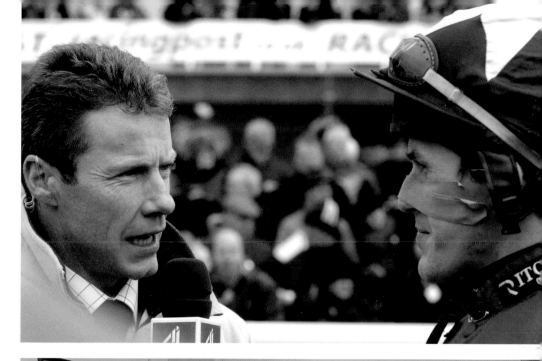

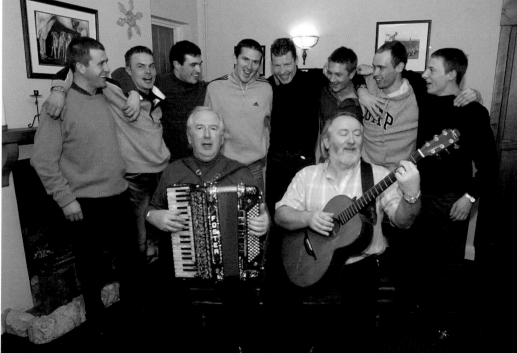

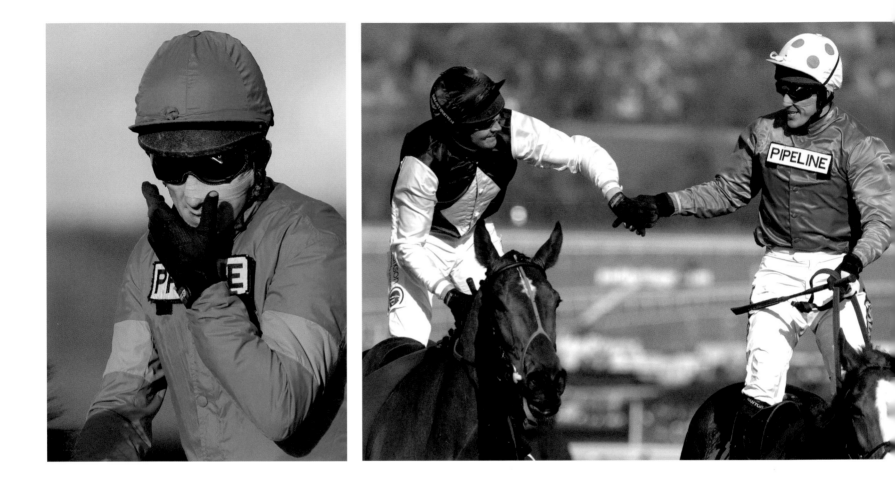

## WOUNDED WARRIOR

*Above left:* Ludlow, 25 February 2004: a shattered cheekbone does not stop a champion.
*Above right:* Cheltenham, 16 March 2004: the plaster is still there at the end of the Arkle Chase. McCoy on Well Chief has just beaten Barry Geraghty on Kicking King. See page 72 for the moment of triumph.

## A WINNER ON THE FIRST RIDE BACK

Ludlow, 25 February 2004: Jardin Fleuri wins the Selling Hurdle.

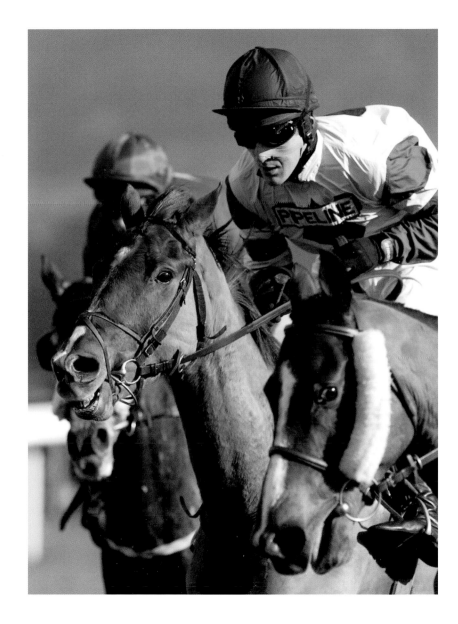

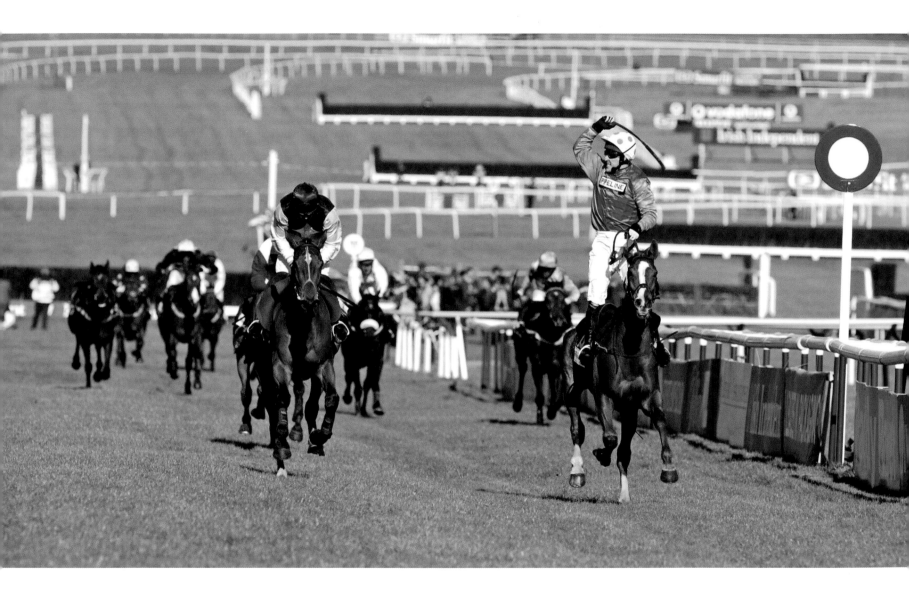

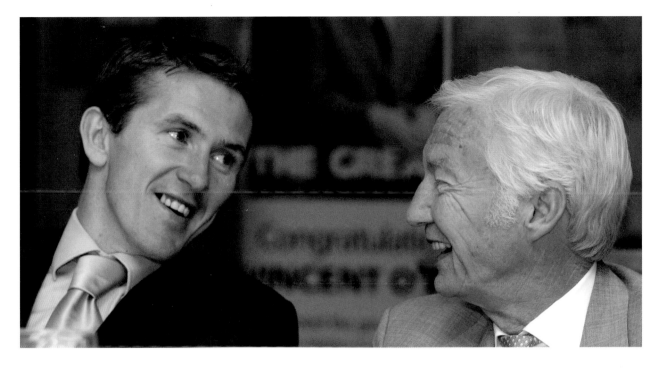

**Above RACING GREATS**

Goring Hotel, London, 5 June 2003: AP and Lester Piggott share
a joke at the *Racing Post* 'Racing Greats' lunch in London.

**Right MODESTY PRESERVED – JUST**

Cheltenham, 16 November 2003: AP poses with Betfair girls
in the weighing room at Cheltenham.

**Opposite THE VICTORY SALUTE**

Cheltenham, 16 March 2004: Well Chief wins the Arkle
from Kicking King.

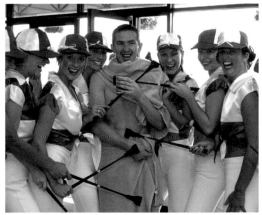

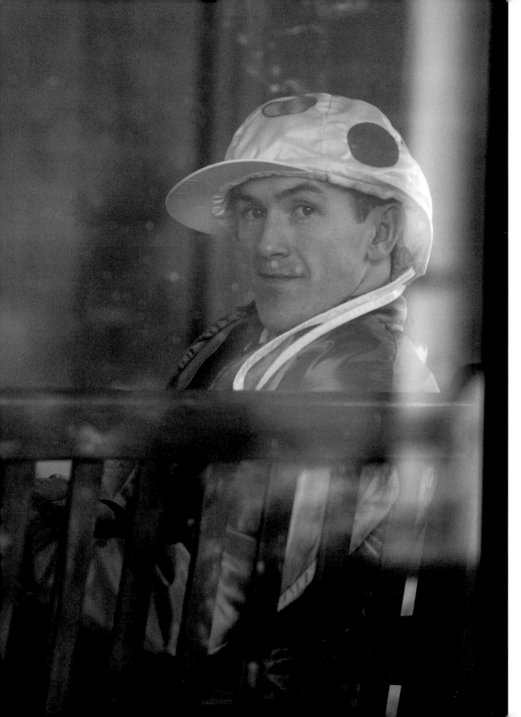

## NEW YEAR RESOLUTION?

Cheltenham, 1 January 2004: a thoughtful McCoy after being banned for breaking the whip rules.

*Right* TRAINER AND JOCKEY

Jackdaws Castle, 15 November 2007:
AP and Jonjo O'Neill pose to celebrate
Jewson's sponsorship of the stable.

*Bottom* MASTER AND APPRENTICE

Newbury, 23 March 2007: champion
jockey McCoy with champion conditional
rider Tom O'Brien in the weighing room.

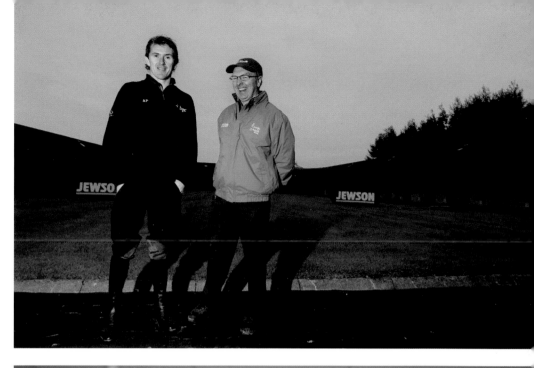

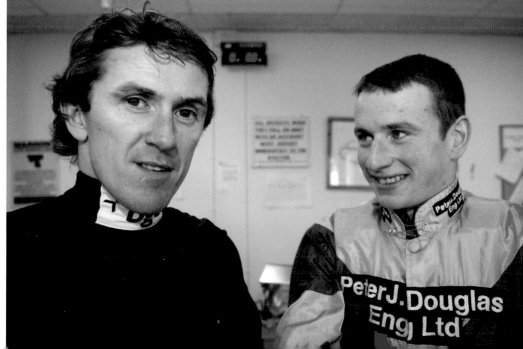

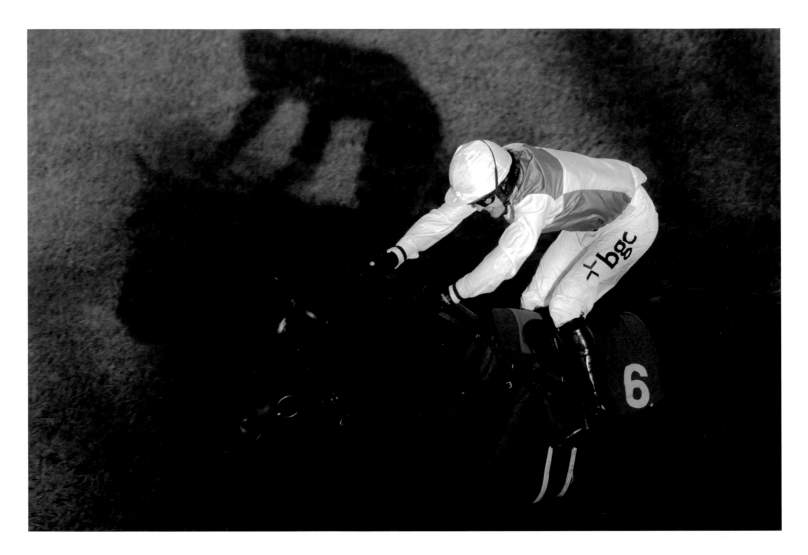

CASTING A LONG SHADOW

Ludlow, 1 March 2007: McCoy and
Parkinson on the run-in.

*Opposite* TOUGH GUY, TOUGH LADY

Cheltenham, 25 January 2003: McCoy and the mare Lady Cricket in the
thick of the battle before winning at Cheltenham.

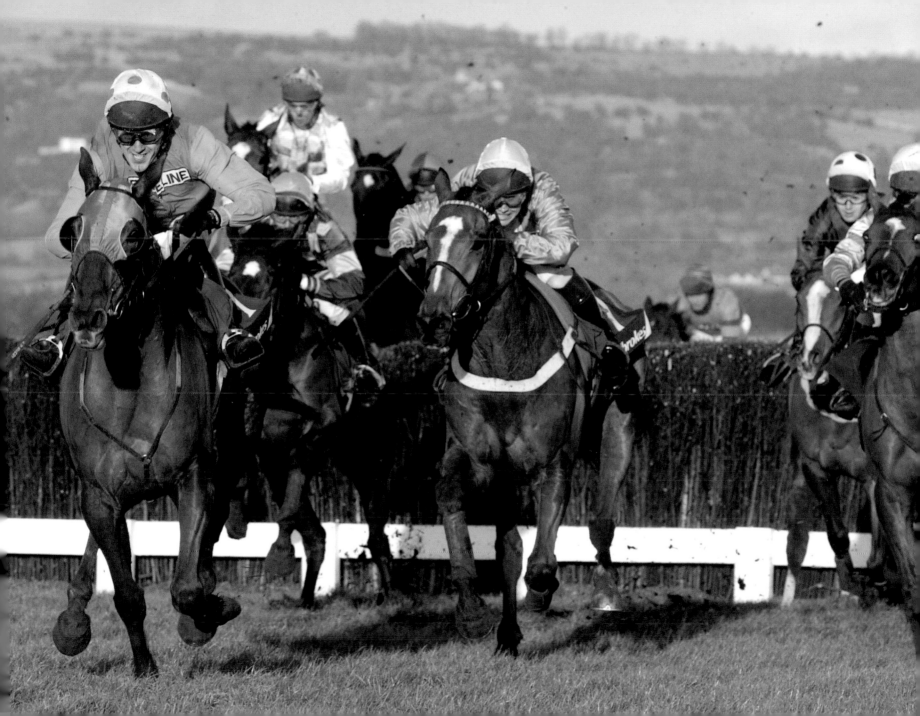

# STORMING CLEAR
# 2008–2011

**POWER AND PANORAMA**

Cheltenham, 16 March 2010: AP and
Binocular storm up the stands rail to
win the Champion Hurdle.

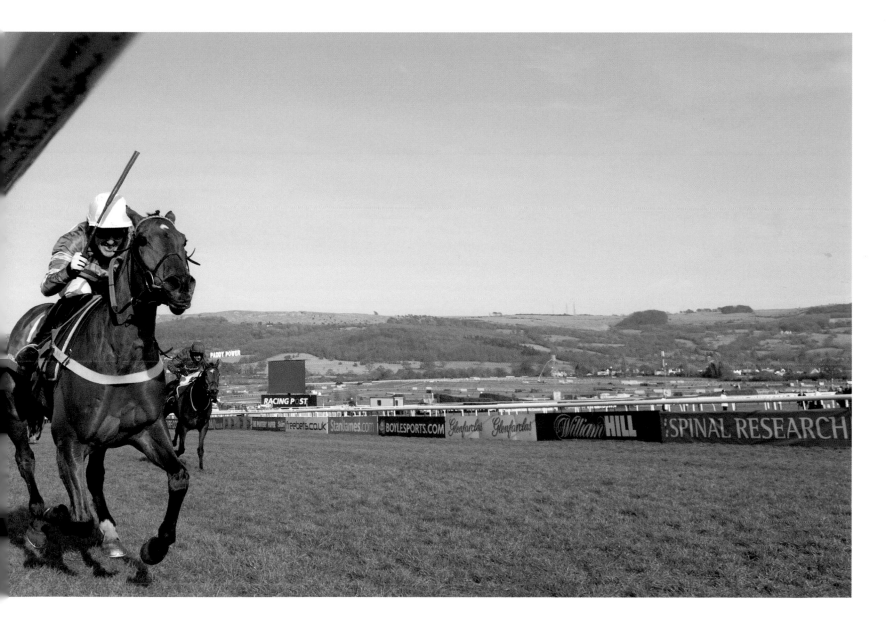

# STORMING CLEAR
## 2008–2011

This is the defining era in his life. It is the era when he got married (page 101), and became a father, and a very good one at that (pages 104-106 and 125). He had great success all over the country and maybe his greatest ever Cheltenham ride on Wichita Lineman (pages 94 and 95).

He continued the unbelievable strain on his body. I remember taking those pictures in John Radcliffe Hospital (pages 82–83). Any 'normal' person injured like that – he had needed surgery on the injured vertebrae in his back – would have been wary of returning because of the risk of paralysis, as well as the possibility of taking anything up to seven months to recover. But there was

an unbreakable belief about McCoy and he duly made the Cheltenham Festival just seven weeks later and was back at Sandown (page 112), with three days to spare.

Within a month he was trying the deep freeze cryotherapy chamber at Champneys (page 84). What you notice is that while the McCoy torso may be honed down, it is one made of whipcord. Above all he is hard because he needs to be. He has to be the man who will absolutely not let a horse lie down with him (page 89). And even if it does (page 97), he is not going to get off in a hurry.

It was the era when the apparently 'impossible' landmark of 3,000

jumping winners was passed (pages 91-92), and when his most coveted victory was finally landed. The 2010 Grand National was success at the 15th attempt. I was right down at the finish line to capture the drive to the line, the thrill of the winning moment and the euphoria of afterwards (see pages 116-121).

Almost better still was the feeling back at Jackdaws Castle, Jonjo O'Neill's Grand National-winning stable. The recognition as BBC Sports Personality at the end of the year (page 124) must have been one of the greatest certainties of all time and we were all as proud as McCoy was when he received the OBE from the Queen in 2011.

*Opposite* FROZEN OFF
Ascot, 17 December 2010: McCoy stands on frozen frost covers at an abandoned Ascot.

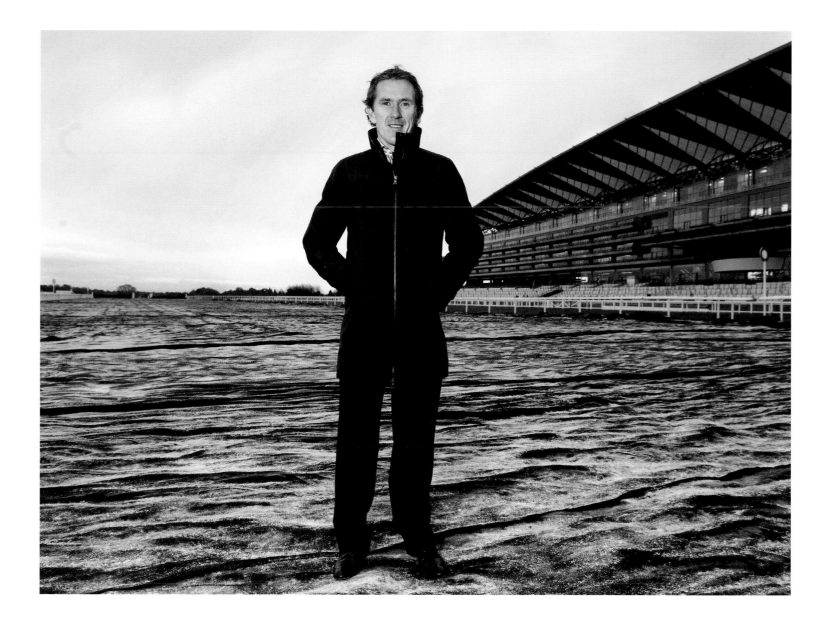

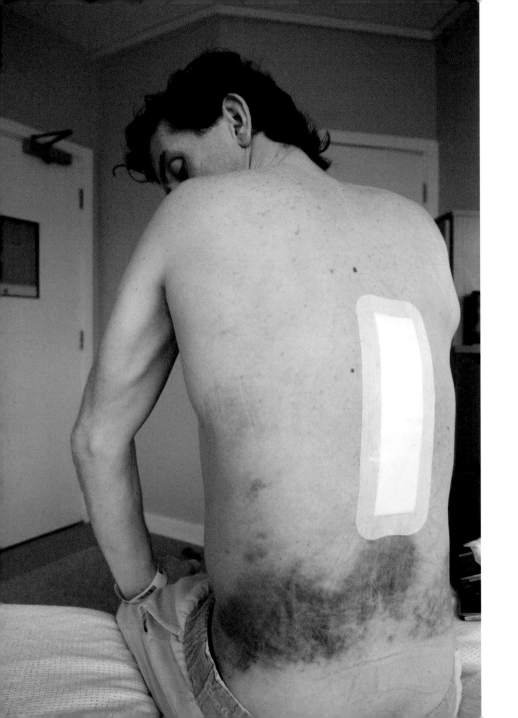

## BRUISED AND BATTERED

John Radcliffe Hospital, Oxford, 19 January 2008: AP shows me his wounds in his hospital room.

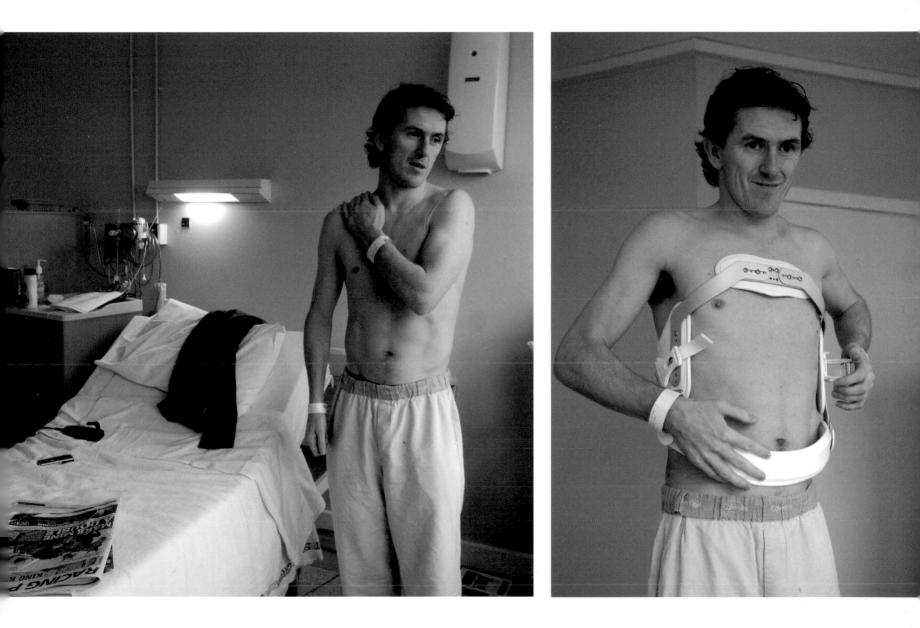

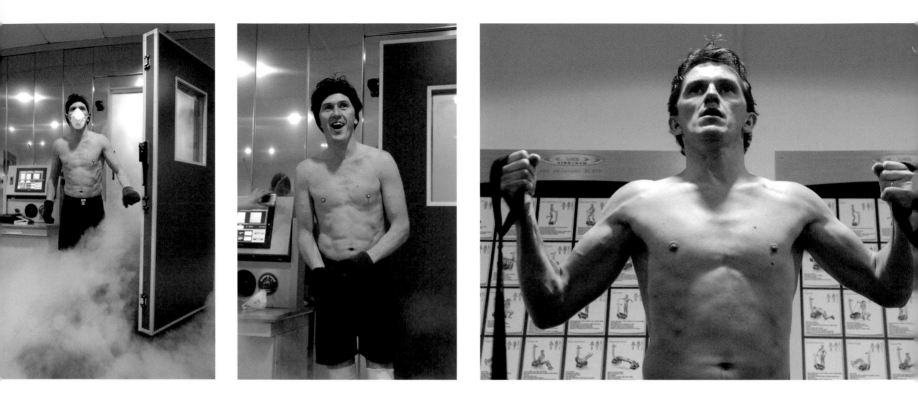

## INVIGORATED BY ICE

Champney's health spa, 19 February 2008:
one month out of hospital, McCoy emerges
from the cryotherapy chamber, where
temperatures go as low as -110ºC.

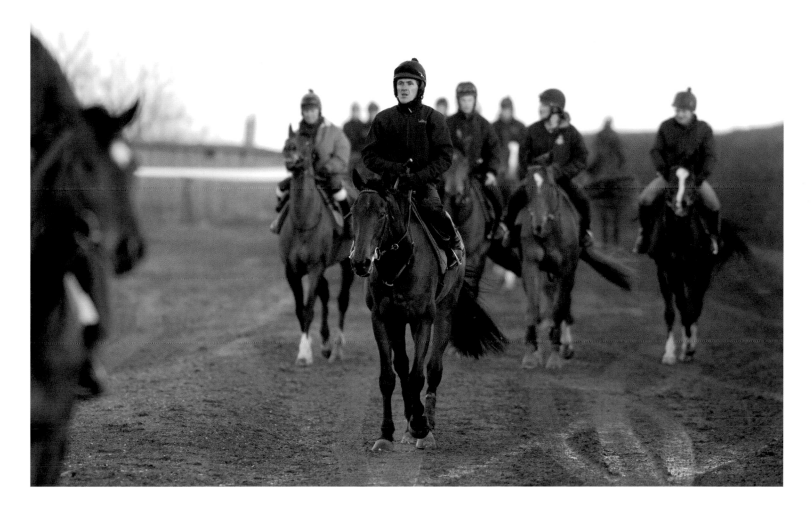

## BACK IN THE SADDLE

Lambourn, 26 February 2008: one week after
the ice chamber, McCoy rides out for trainer
Carl Llewellyn.

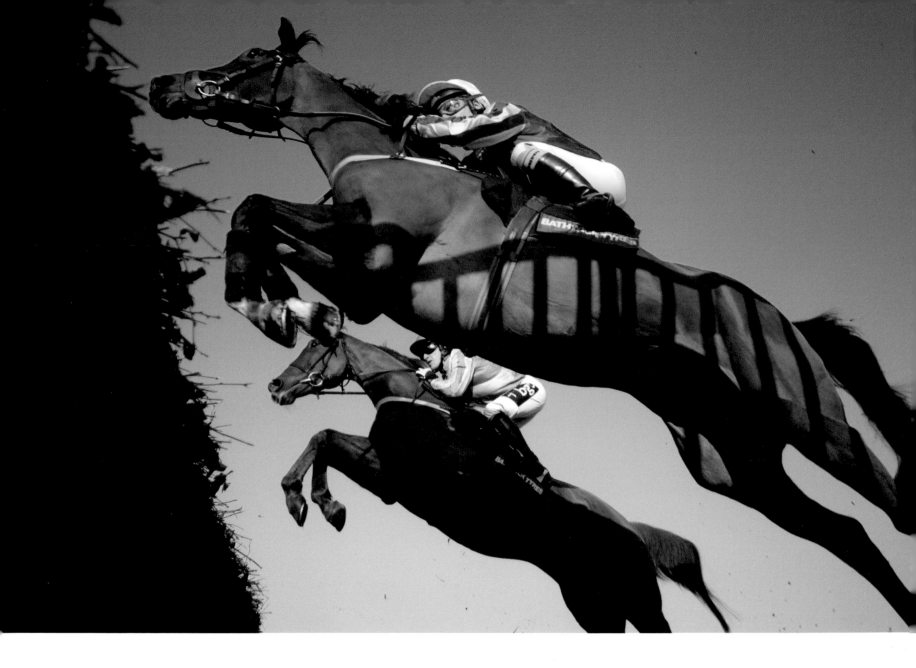

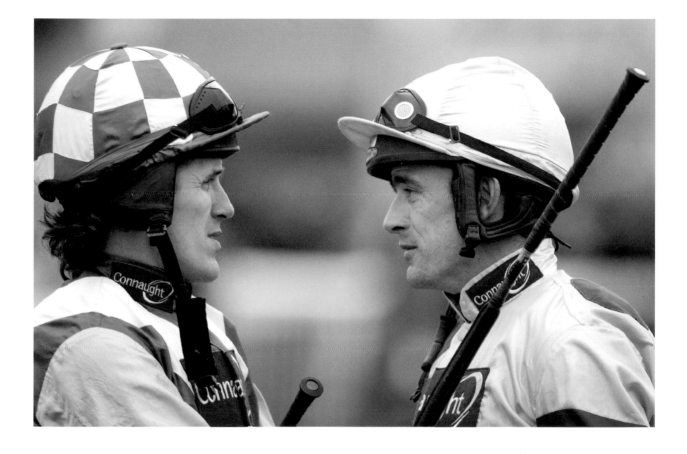

**Opposite LAUNCHING**

Newbury, 29 December 2008: I love this picture – the commitment and the sky. McCoy (*far side*) reaches up the neck of Gone To Lunch at the open ditch. Jimmy McCarthy on Sir Bathwick is closest to us.

**ADVICE NEEDED**

Newbury, 13 February 2010: McCoy and Walsh together in the paddock before the Aon Chase. AP is to have a preparatory ride on Denman in it, ahead of the Cheltenham Gold Cup (see page 88) in which Walsh, Denman's usual rider, will be aboard Kauto Star. The rehearsal would not go to plan.

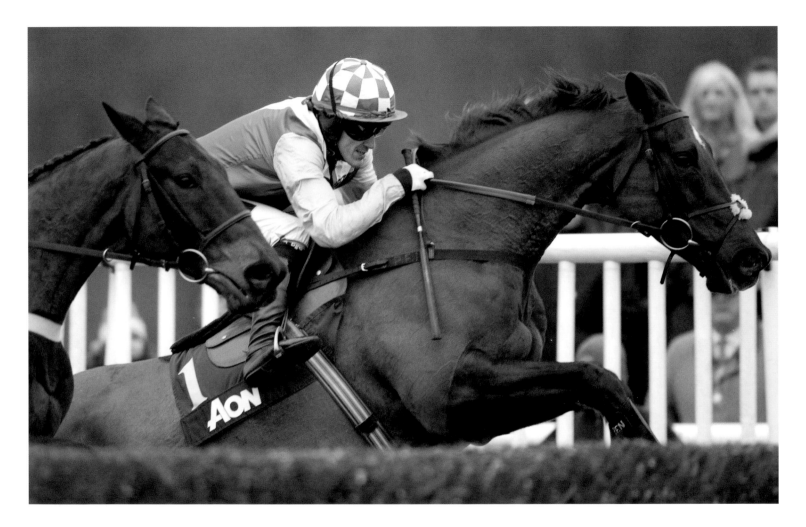

## SO FAR, SO GOOD

Newbury, 13 February 2010: Denman, 1-6 favourite, and new jockey McCoy seem in command on the first circuit, but Denman's jumping would fail, and see him fall three out.

*Opposite* SITTING TIGHT

Newbury, 13 February 2010: one race after the Denman debacle, McCoy clamps limpet-tight on Get Me Out Of Here before winning the big totesport Hurdle.

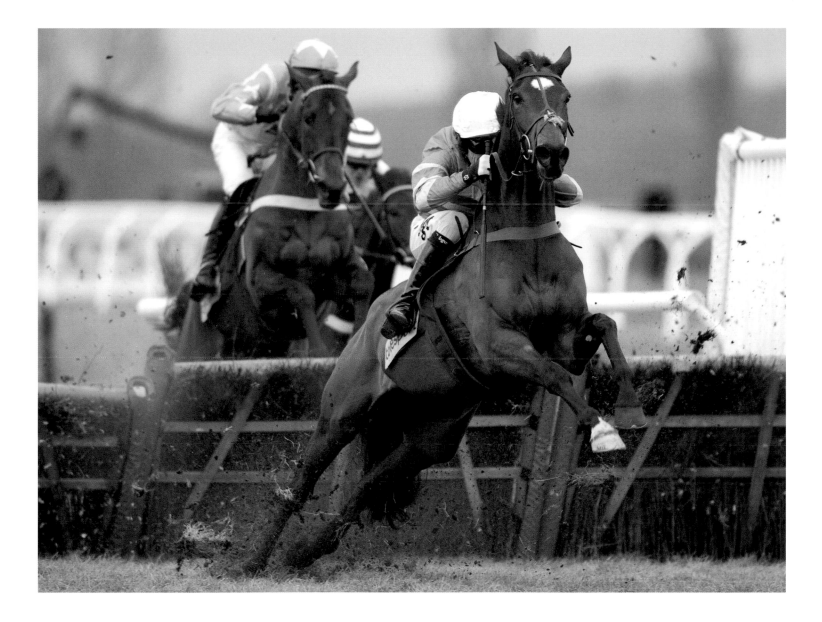

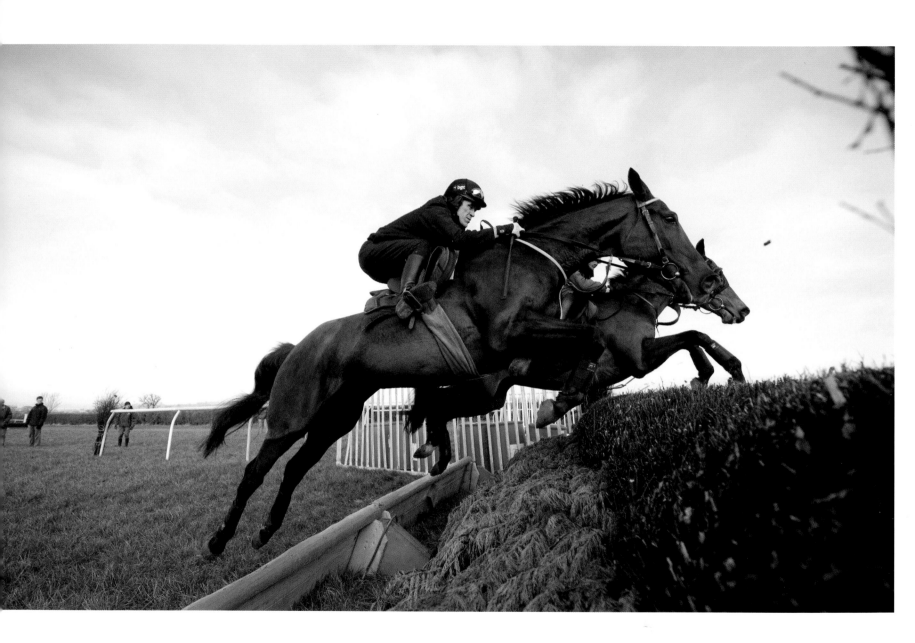

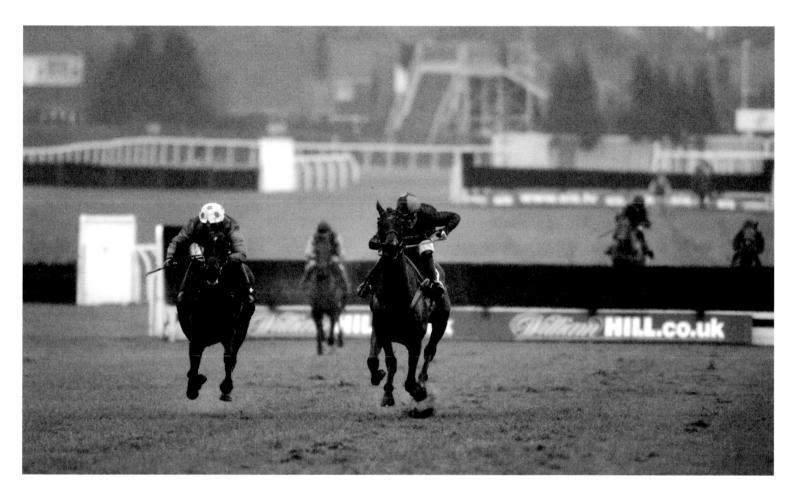

**_Opposite_ GETTING IT TOGETHER**

Paul Nicholls' schooling grounds at Ditcheat, Somerset, 11 March 2010: McCoy puts Denman through a jumping session in readiness for their Gold Cup run, in which they finished an honourable second, with Walsh and Kauto Star taking a crashing fall four from home.

**3,000 WINNERS**

Plumpton, 9 February 2009: McCoy drives Restless D'Artaix home in gathering darkness. There is no mistaking the compulsion in his body language.

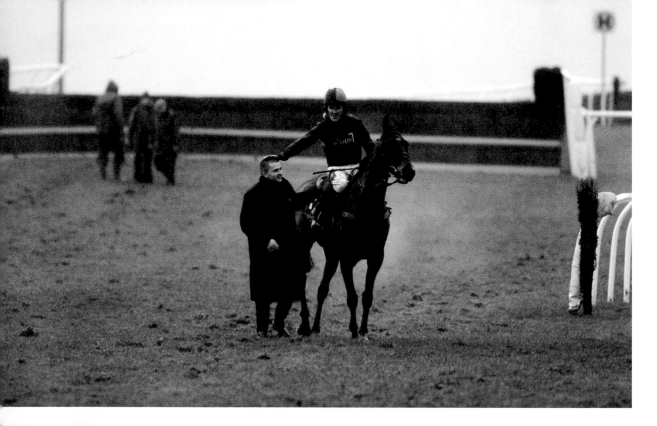

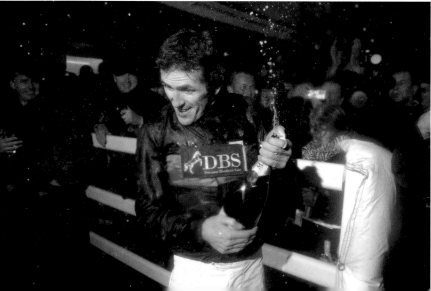

***Above*** THE HAND OF THANKS

Plumpton, 9 February 2009: Dave Roberts, McCoy's long-standing agent, has made one of his very rare trips to the races to see his client's 3,000-winner milestone.

***Left*** NOT EXACTLY FORMULA ONE

Plumpton, 9 February 2009: but these celebrations had been much harder to earn.

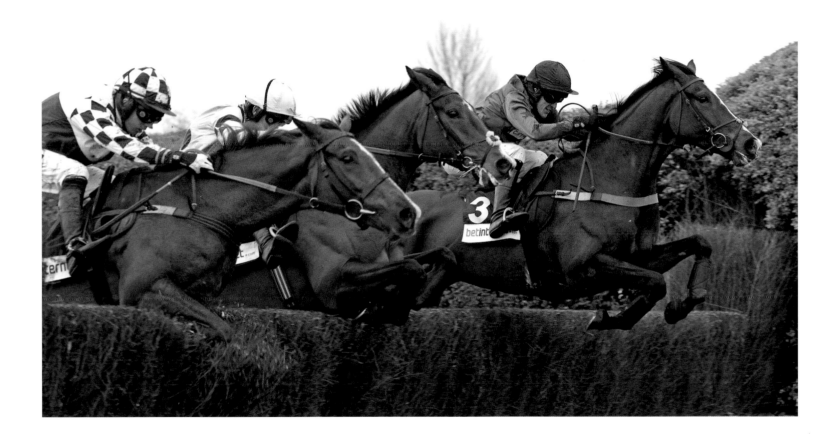

## GOING FOR HOME

Sandown Park, 5 December 2009: McCoy on Somersby (*far side*) is in full-flight commitment over the last fence before winning the Henry VIII Chase from Crack Away Jack (*nearside*, Noel Fehily) and Tchico Polos (Ruby Walsh, *centre*).

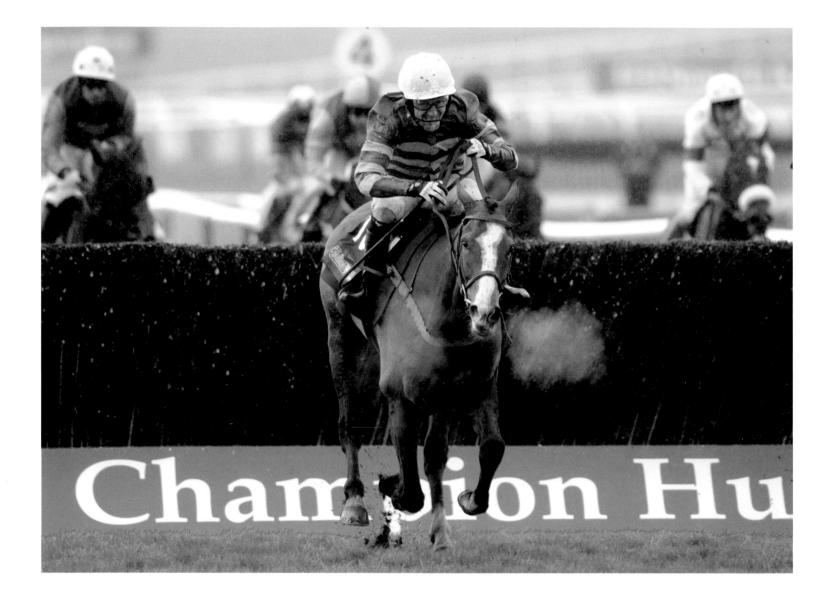

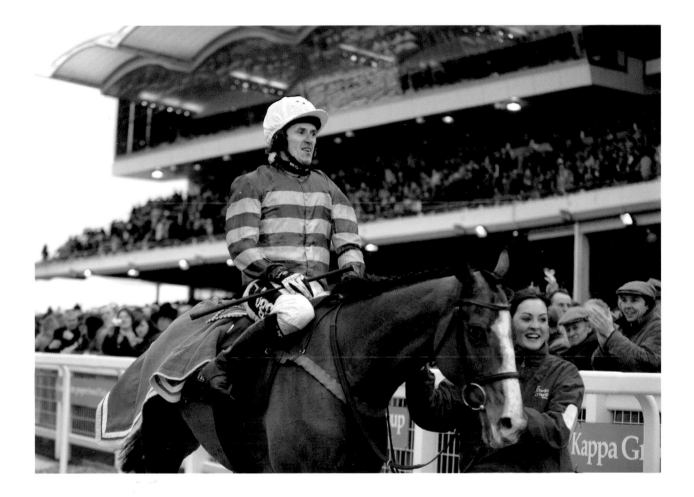

***Opposite* FESTIVAL BEST?**

Cheltenham, 10 March 2009: Wichita Lineman wins the
William Hill Trophy after what many people think was McCoy's most
compelling ride of all, getting up by a neck after being in
what seemed an impossible position a mile earlier.

**TAKING THE APPLAUSE**

Cheltenham, 10 March 2009:
you can't miss the satisfaction on
McCoy's face. Wichita Lineman
had been given quite a ride.

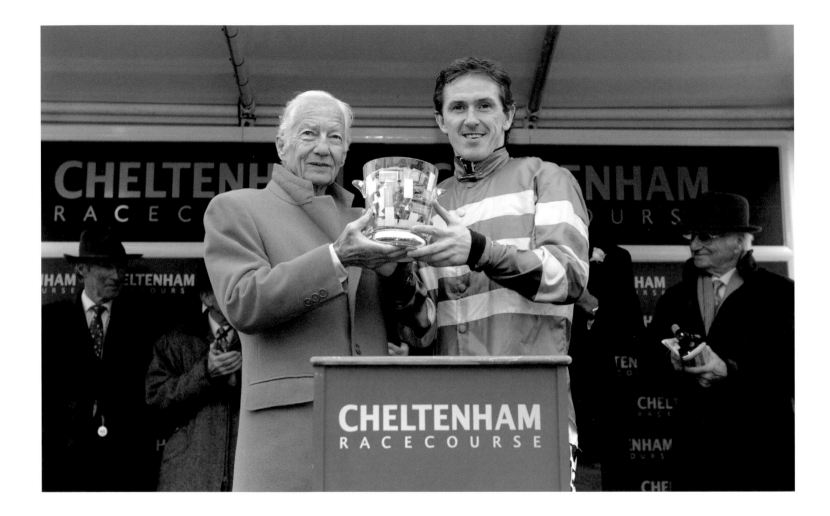

TAKES ONE TO KNOW ONE

Cheltenham, 13 March 2009: Lester Piggott presents McCoy
with a special award to mark his 3,000 winners.

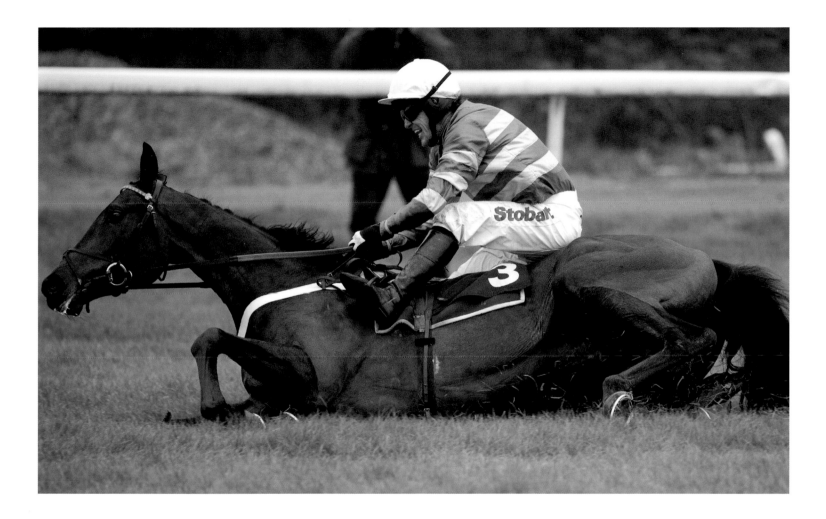

## DON'T ABANDON SHIP

Lingfield, 22 November 2011: McCoy is still in the saddle as Kid Cassidy
hits the ground at the third-last fence at Lingfield.

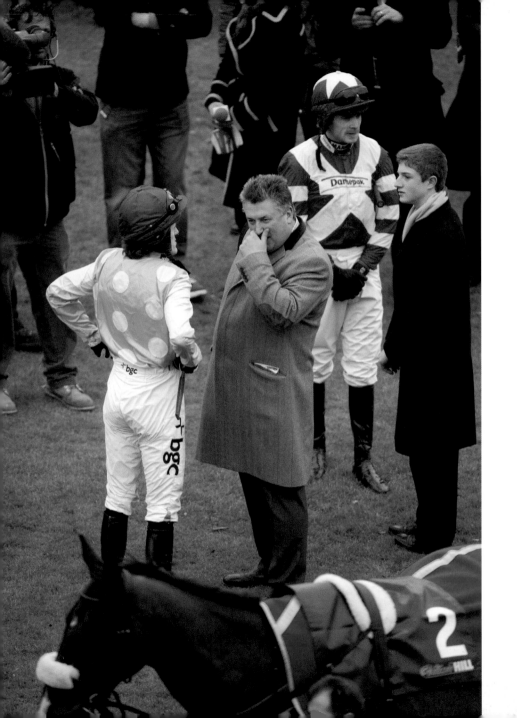

## READY FOR BATTLE

Kempton Park, 15 January 2011: McCoy talks to Paul Nicholls before deputising for the injured Ruby Walsh on Kauto Star in the King George VI Chase, which had been postponed from Boxing Day. Sam Thomas stands by ready to ride The Nightingale, and Nicholls' nephew Harry Derham looks on.

*Opposite* YOUNG LION, OLD LION

Kempton, 15 January 2011: the six-year-old Long Run (Sam Waley-Cohen) leads his five-years senior Kauto Star and McCoy across the Kempton all-weather strip with a circuit to race.

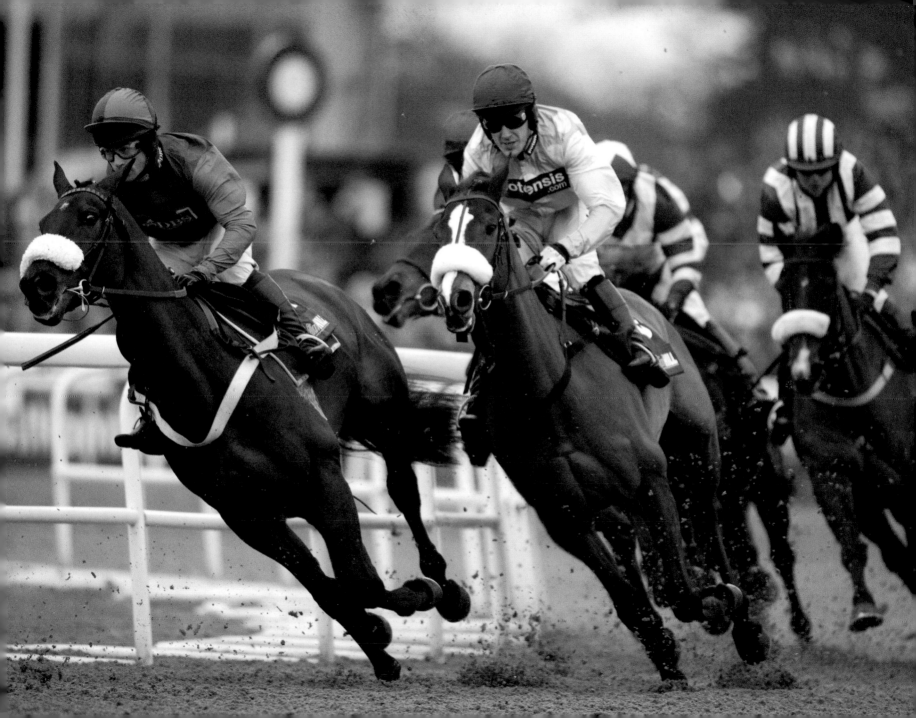

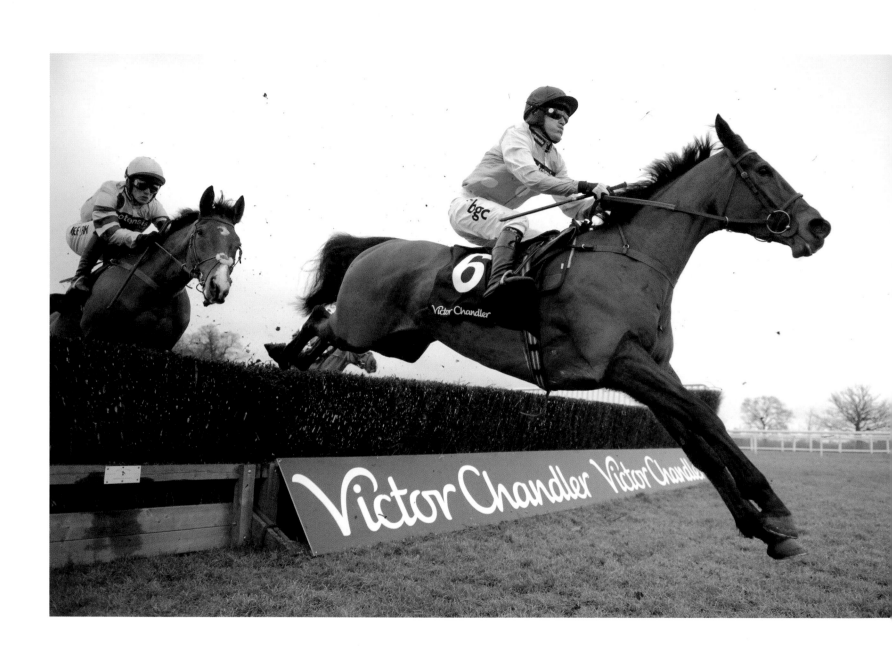

*Above* MARRIED LIFE

Membury, 28 January 2011: AP McCoy still busy as he leaves the new marital home above Lambourn.

*Right* A DAY AT THE RACES

Cheltenham, 29 January 2011: Mr and Mrs McCoy hold hands at the racecourse.

*Opposite* ANOTHER RUBY WALSH STAND-IN

Ascot, 22 January 2011: McCoy rides the star two-mile chaser Master Minded for Paul Nicholls over the first fence in the Victor Chandler Chase, before winning by just a short head.

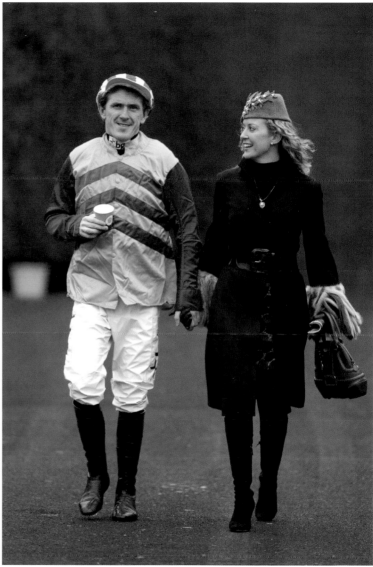

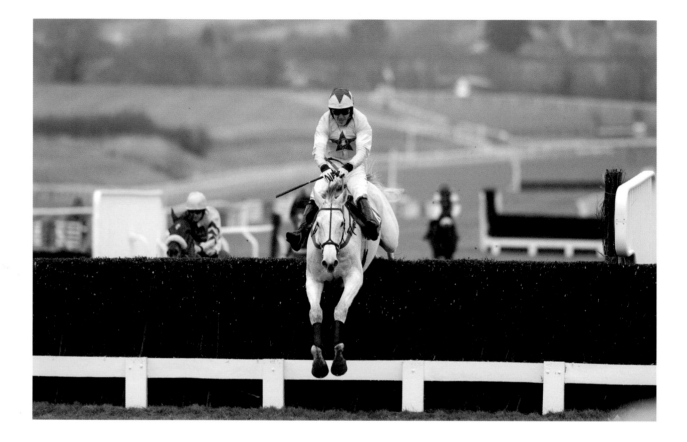

**CENTRE STAGE**

Cheltenham, 29 January 2011: McCoy and the grey Neptune Collonges jump the last fence before winning the Argento Chase.

*Opposite* AWKWARD UNSADDLING

Cheltenham, 29 January 2011: McCoy and Neptune Collonges with trainer Paul Nicholls and owner John Hales.

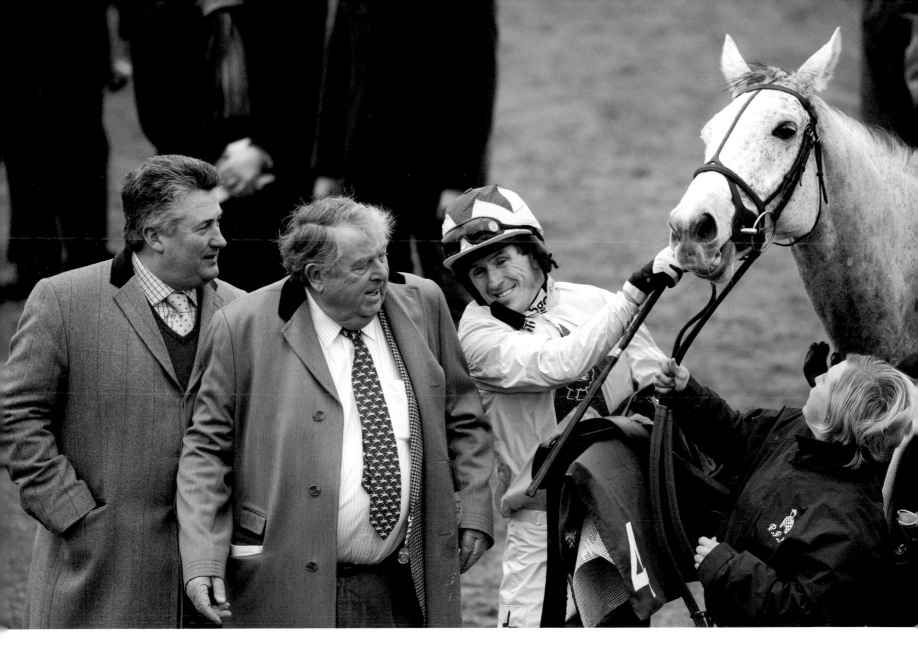

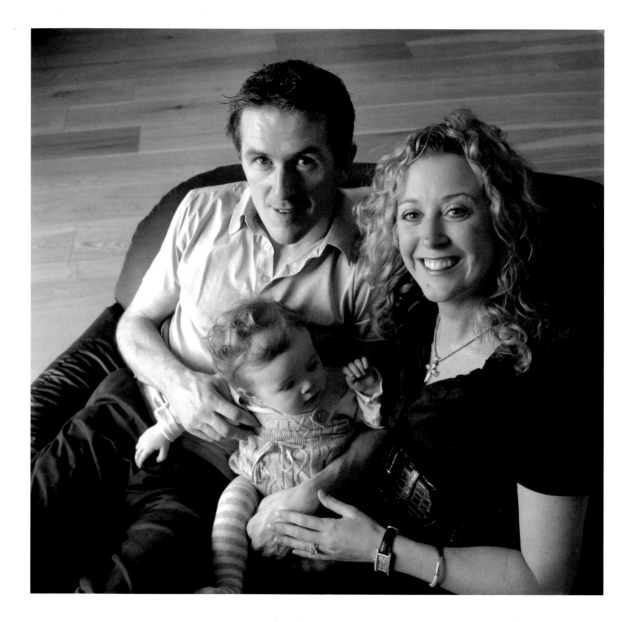

## OUR LITTLE MIRACLE

Membury, 26 January 2009:
Eve McCoy – 'the child we thought
we would never have.'

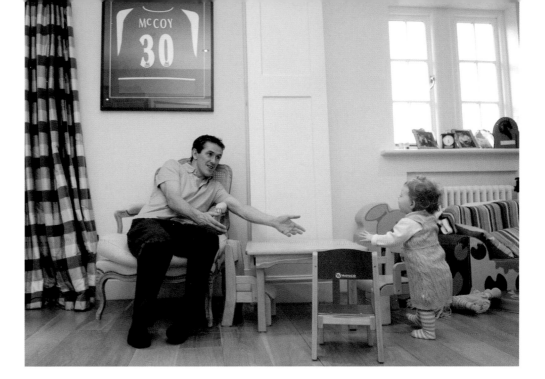

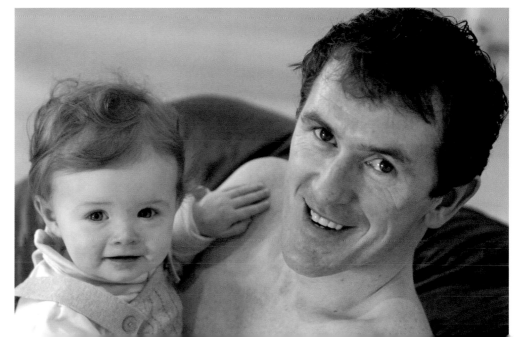

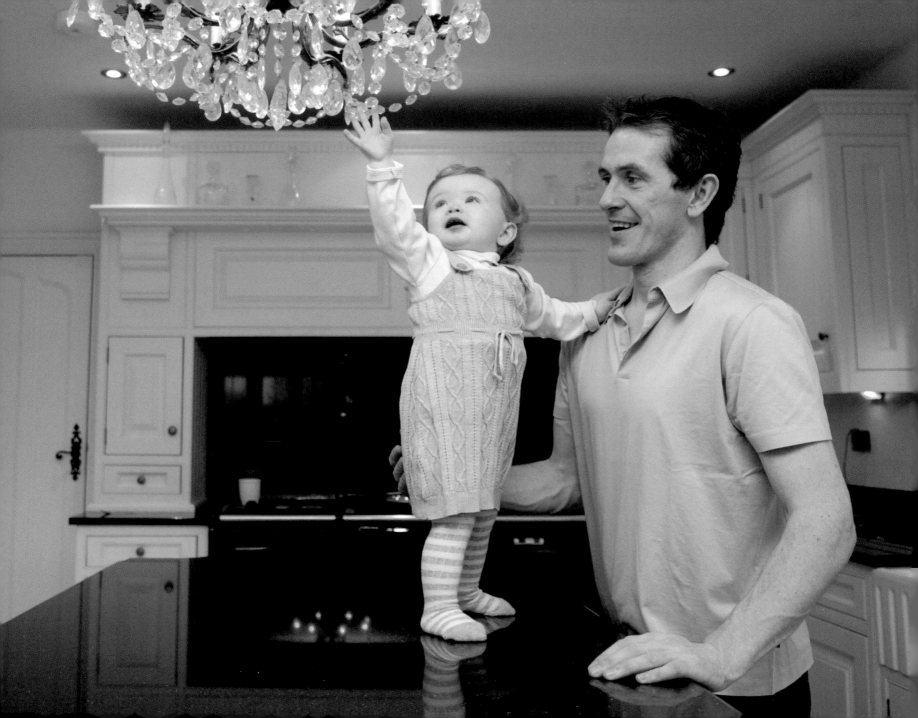

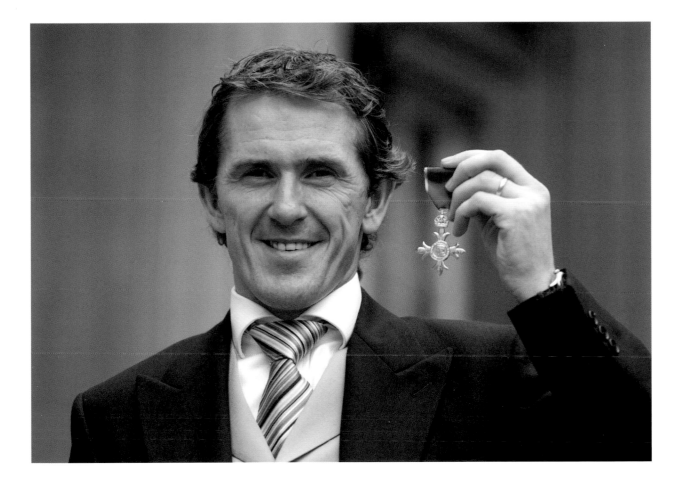

*Opposite* REACHING FOR THE STARS

Membury, 26 January 2009: the adoration of father for daughter was obvious in his every move.

DR A.P. MCCOY OBE

Buckingham Palace, 28 June 2011: that was his official title – an honorary doctorate from Belfast University – for the investiture.

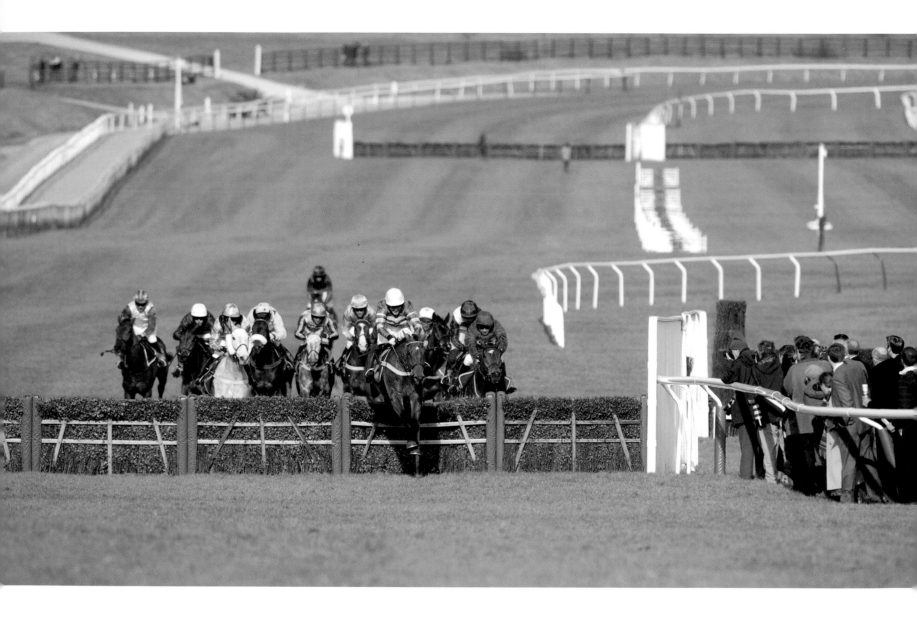

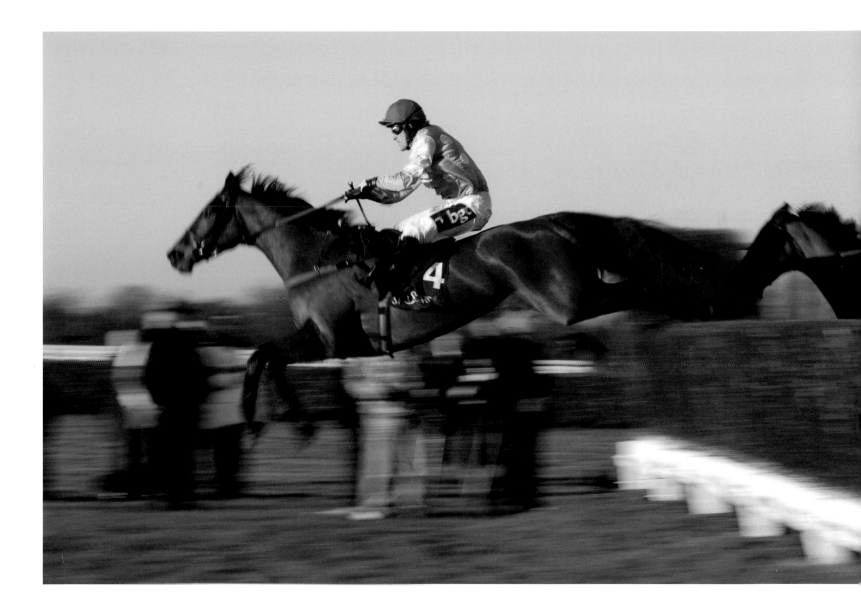

*Previous spread, left* SETTING THE PACE

Cheltenham, 16 March 2010: McCoy and Binocular lead the Champion Hurdle field over the last, before powering home.

*Previous spread, right* THE BLUR OF SPEED

Sandown Park, 6 December 2008: McCoy and Master Minded fly over the second-last fence before winning the two-mile Tingle Creek Chase.

*Left* WISTFUL IN THE WINDOW

Exeter, 20 October 2009: McCoy shelters from the wind and rain as the runners gather for the opening race, an amateurs' hurdle for which he must have been pleased to be ineligible.

*Opposite* THE SHINING

Sandown Park, 13 February 2009: McCoy and Torphichen jump the last to win the juvenile hurdle. Sometimes the winter light can be magical.

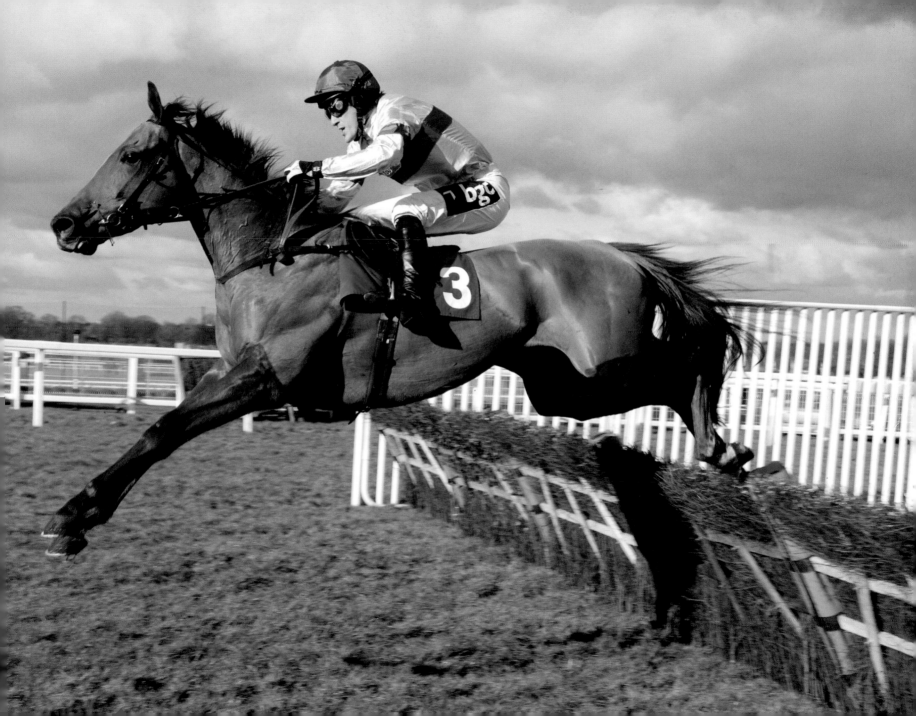

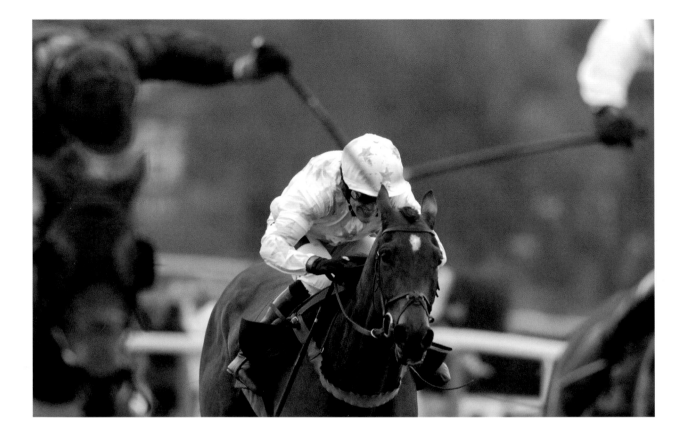

BACK IN ACTION

Sandown, 8 March 2008: McCoy on Rapid
Increase drives up the hill to finish fifth, on
his first ride back from the back injury (see
pages 84-5).

*Opposite* IN THE STORM

Exeter, 11 November 2008: McCoy and
David Pipe stand in a hail shower before
Another Display finishes sixth in the
novice hurdle.

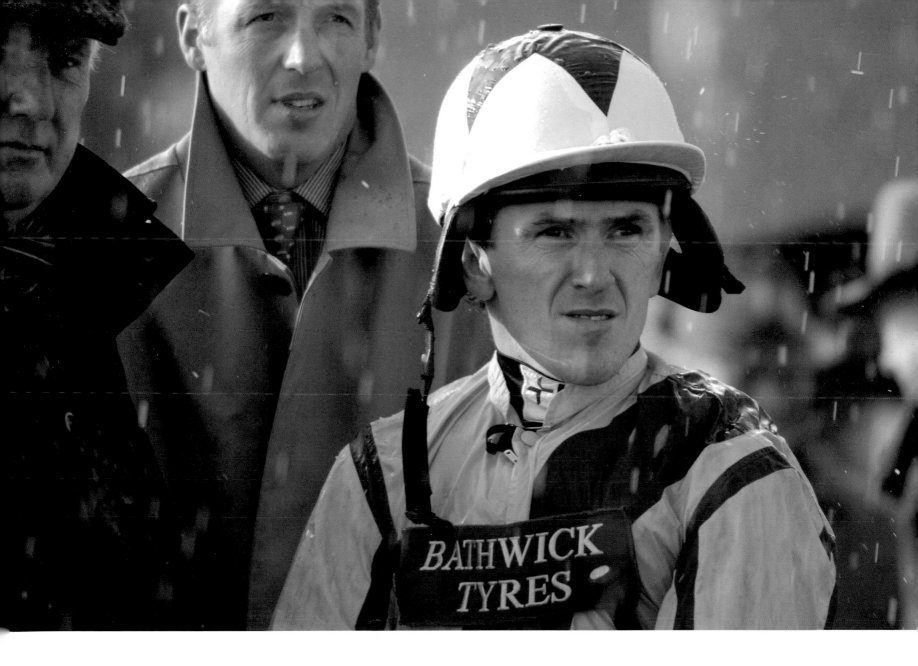

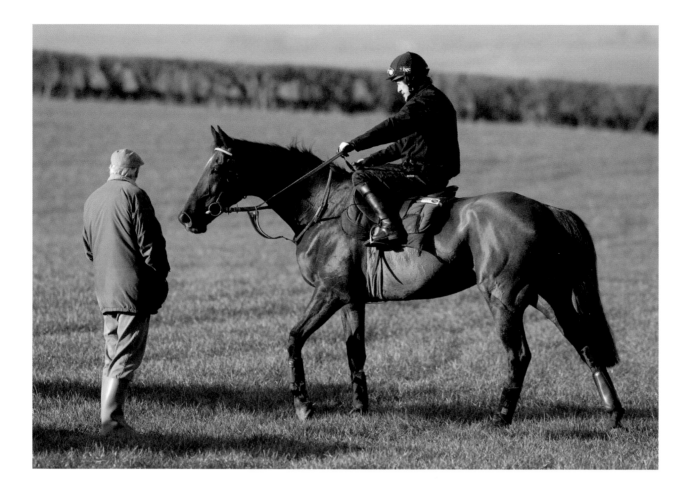

FINE TUNING

Ditcheat, 11 March 2010: owner Paul
Barber watches McCoy prepare to school
Denman, ready for the Cheltenham Gold
Cup a week later.

*Opposite* EVENING EMBERS

Cheltenham, 10 December 2010:
McCoy wins on Prince Of Pirates as
the late afternoon sun burns orange
into Cleeve Hill.

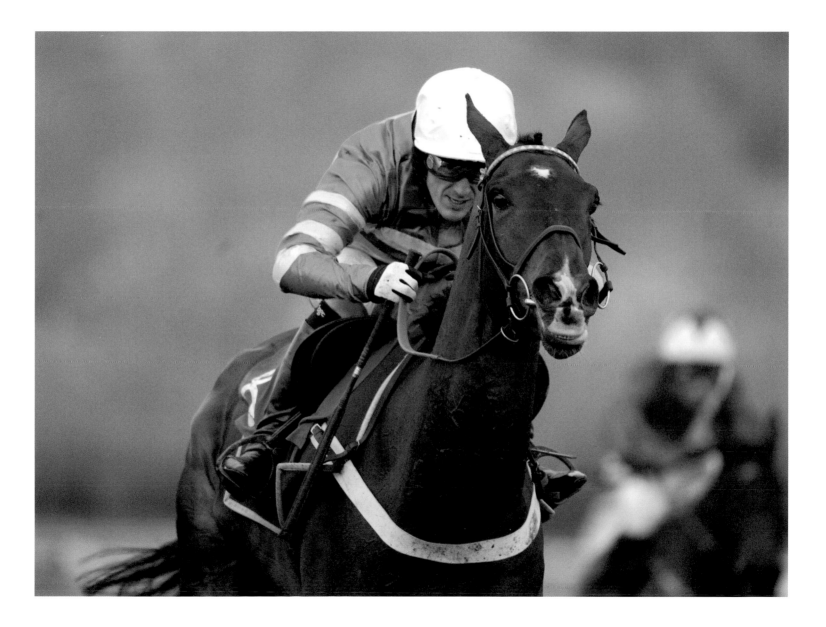

## ROCKING TO GLORY

Aintree, 10 April 2010: McCoy drives
Don't Push It towards the so-coveted
Grand National winning line.

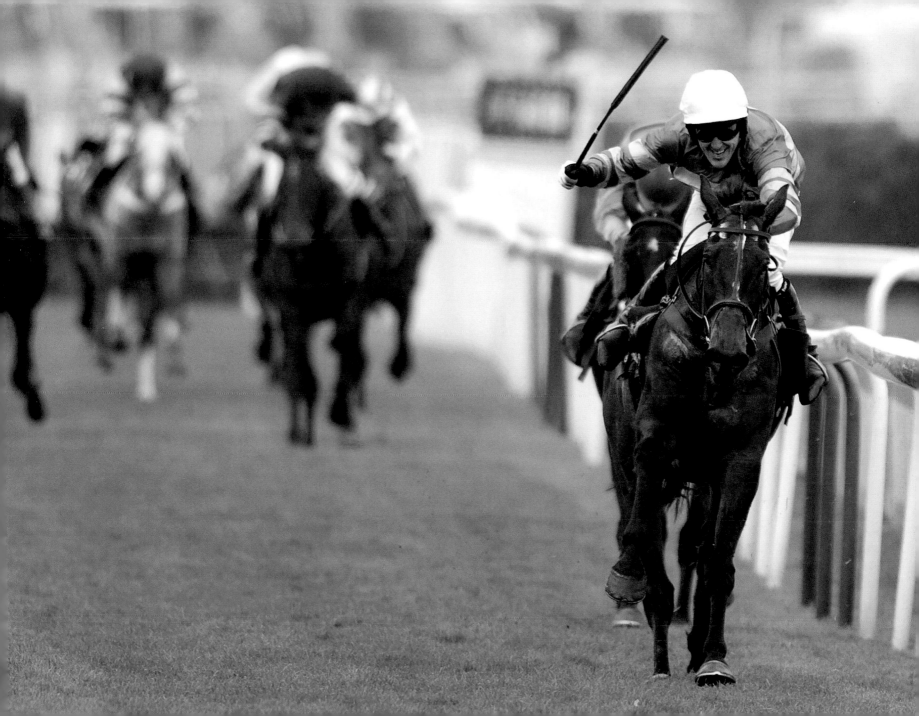

## DONE IT

Aintree, 10 April 2010: Tony McCoy wins the Grand National at the 15th attempt. I was shooting the finishing line head-on, and the emotion as he passed the post was overwhelming.

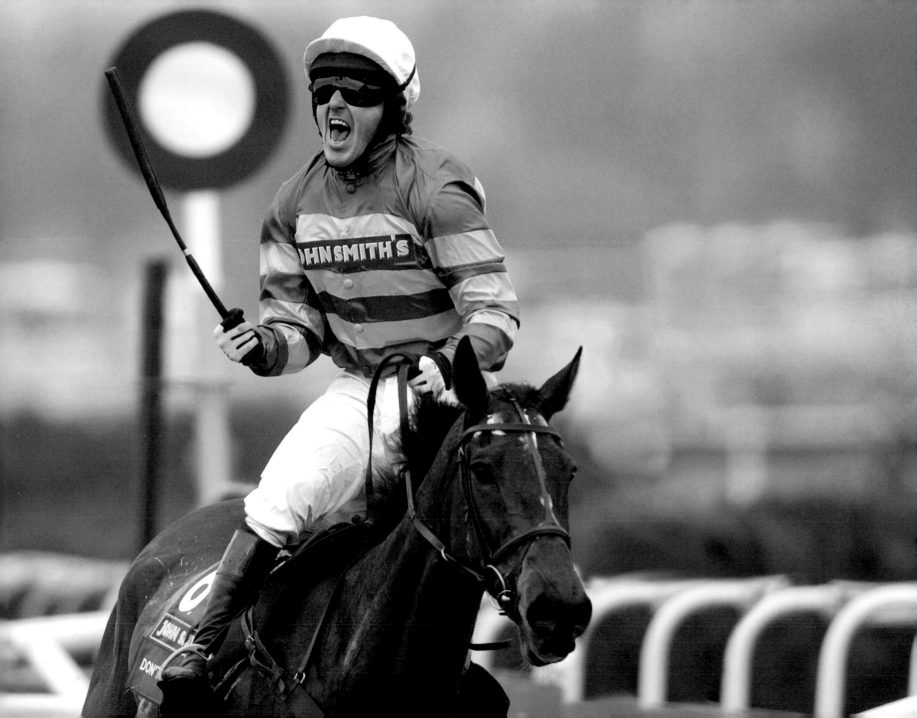

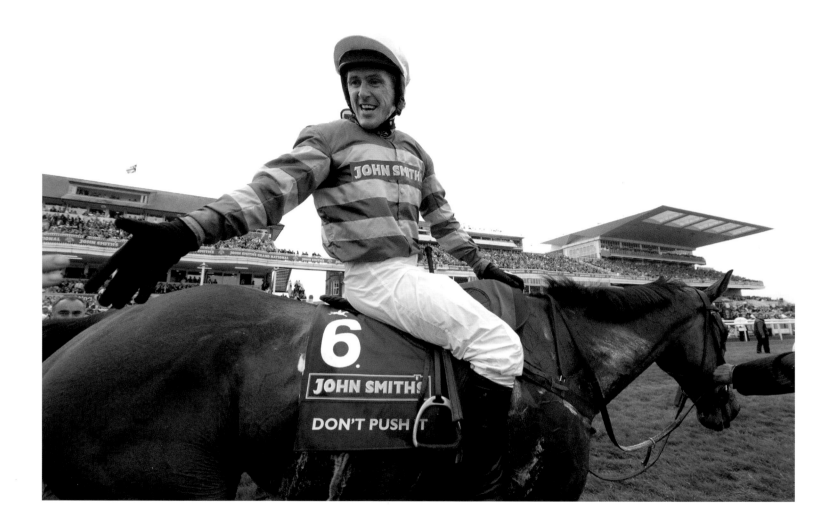

GRAND NATIONAL GLORY

Aintree, 10 April 2010: handshakes all round.

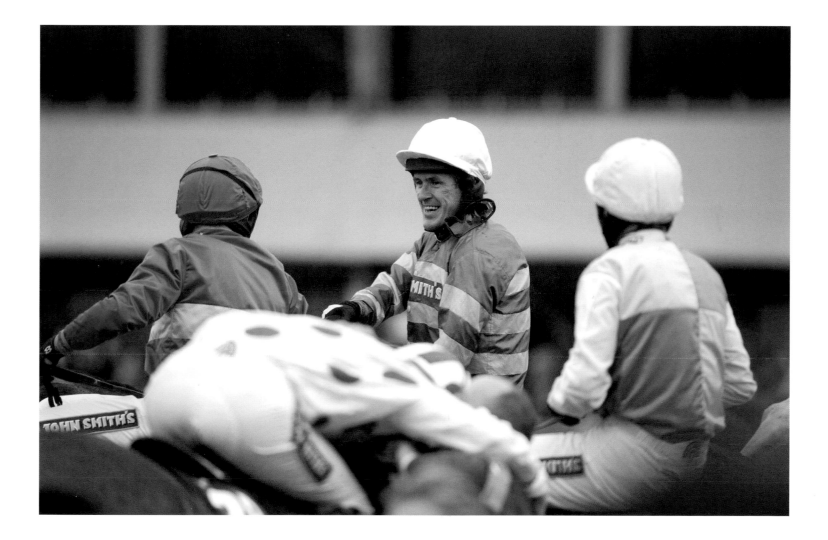

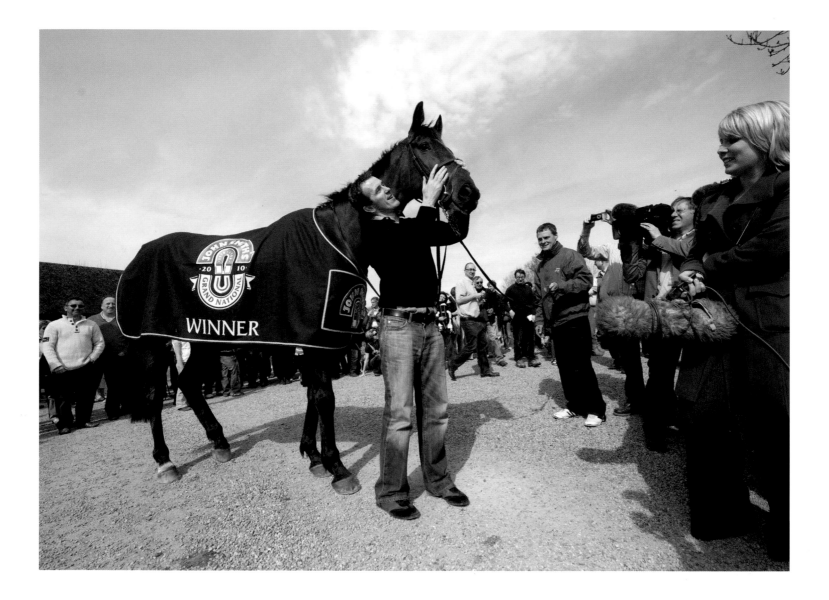

## THE MORNING AFTER

Jackdaws Castle, 11 April 2010: AP and
Don't Push It pose for the cameras. Among
the well-wishers are wife Chanelle and
slightly doubtful daughter Eve.

BBC SPORTS PERSONALITY OF THE YEAR

Membury, 20 December 2010: McCoy looks at the trophy. He is the first racing figure to win it.

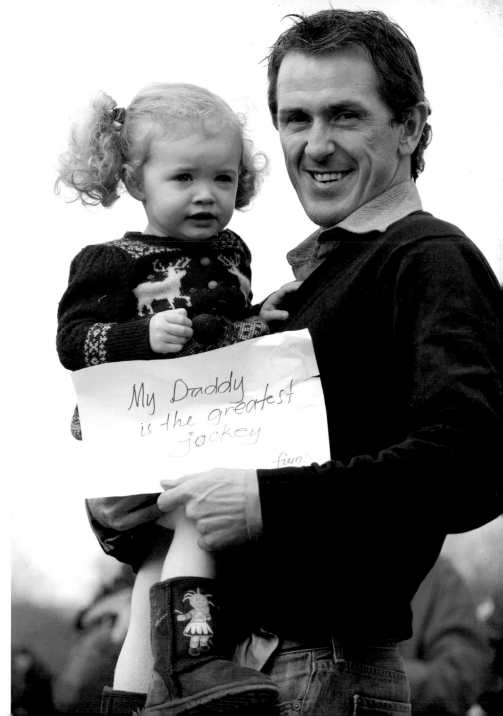

FAMILY FAN

Jackdaws Castle, 11 April 2010: Eve has her own tribute to the Grand National winner.

# THE EVER DISTANT HORIZON
# 2012–2014

Doncaster, 4 February 2013.

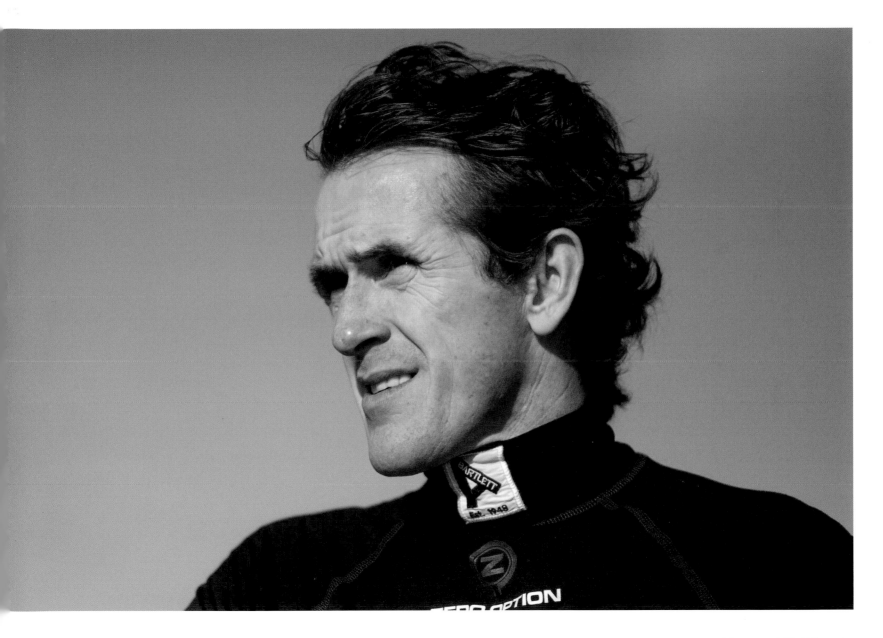

# THE EVER DISTANT HORIZON
## 2012–2014

We were now long into uncharted territory. We had all thought we were into the extraordinary when AP passed 3,000 winners, now he was marching ever onward towards 4,000. Now that really had to be impossible. But of course, with him it wasn't.

Not that there was any escaping the penalties of the game – even looking through the lens I had to wince when he got off Taquin Du Seuil at Cheltenham (page 144). Nor did becoming a senior figure in the game make you any cleaner when the rains came down (page 152). But there was a sort of serenity in the certainty of it all. The near manic youth at the beginning of the book was very different to the

figure on the brink of his 4,000th winner (pages 148 and 149).

For this was a man who had conquered it all, who had taken another Cheltenham Gold Cup, but who needed these seemingly impossible targets to fuel his ambition. That was why the 4,000 winners mattered so much to him and those around him. I don't ever remember seeing JP McManus look so proudly happy as he was that day at Towcester (page 158).

Best of all the winner came with a truly vintage McCoy performance. Two hurdles out, even at the last, he was not going to win. But we

have long got used to the feeling – it shouldn't happen, couldn't happen, but it did. I was down by the winning post and as he came past it was as if he was lifting the horse over the line (pages 156–157). Perhaps he was.

I have now photographed AP McCoy, rain and shine, winter and summer, sick and well, for almost 20 years but in all that time I am not sure I have ever seen him more completely fulfilled as when he stood with that 4,000 winner trophy in the gathering gloom at Towcester.

*Opposite* LEADING OUT
Taunton, 19 February 2013: McCoy walks into the paddock in the McManus silks.

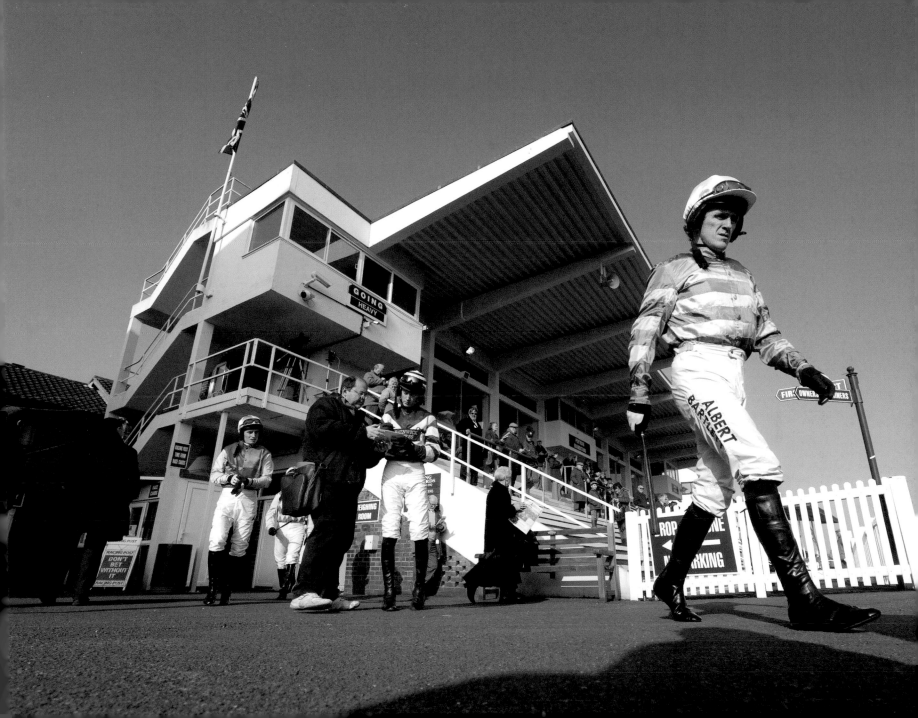

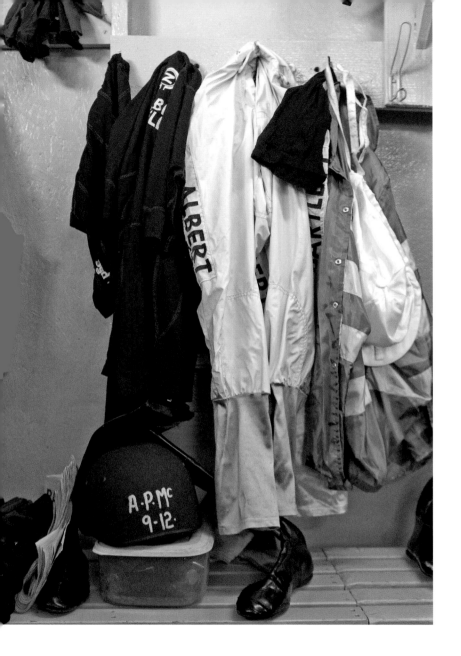

## CHAMPION'S KIT

Hereford, 5 December 2012: undershirt, breeches, silks, boots and helmet, laid out by valet Chris Maude ready for the day's action.

*Opposite* TWO TO GO

Chepstow, 6 November 2013: McCoy weighs out before riding El Macca in the novice hurdle at the start of the day. He was on 3,998 winners. El Macca was only fifth, but one more success that day brought him to the very brink of the once-unthinkable 4,000.

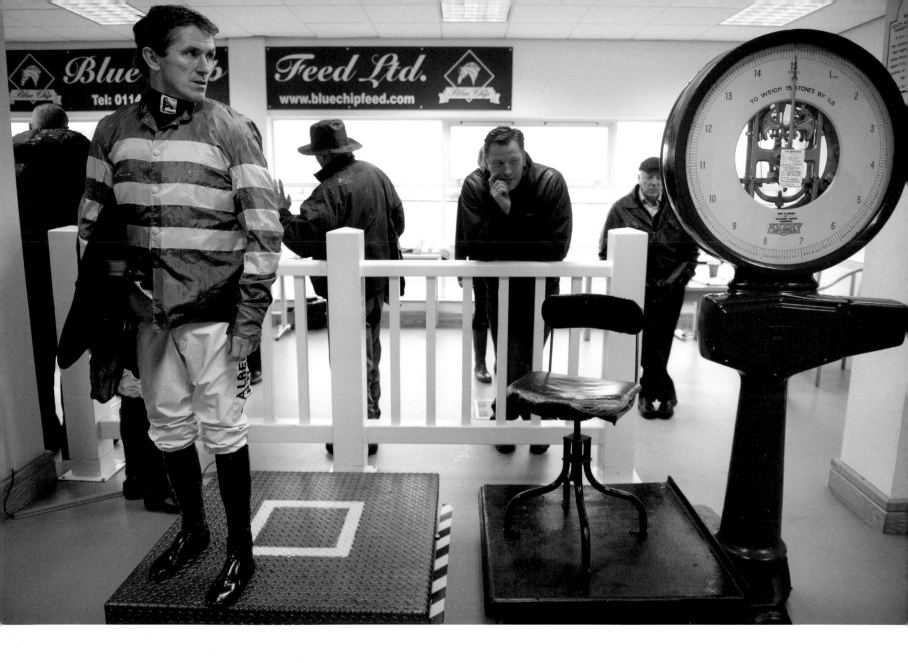

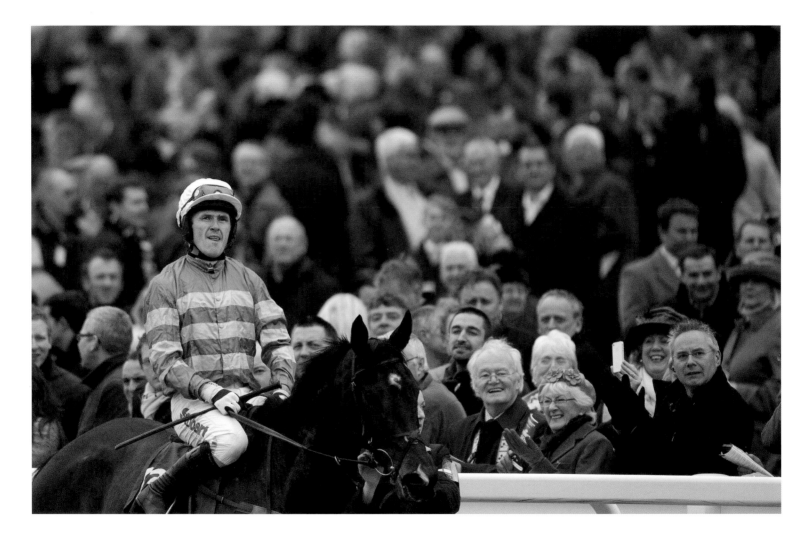

THAT'S HOW WE DID IT

Cheltenham, 16 March 2012: McCoy looks across at the race replay on the big screen after he and Alderwood have won the Vincent O'Brien County Hurdle at the start of Gold Cup day.

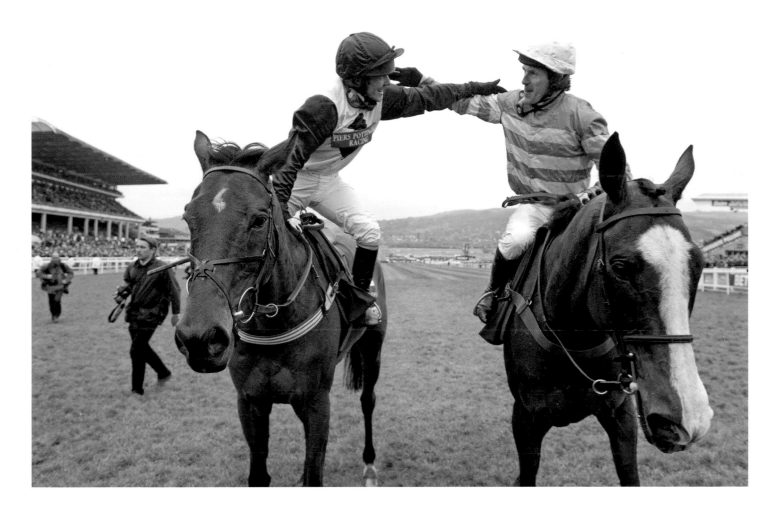

## THE CONGRATULATORY ARM

Cheltenham, 16 March 2012: McCoy is congratulated by Carruthers' jockey
Mattie Batchelor after winning the Gold Cup on Synchronised.

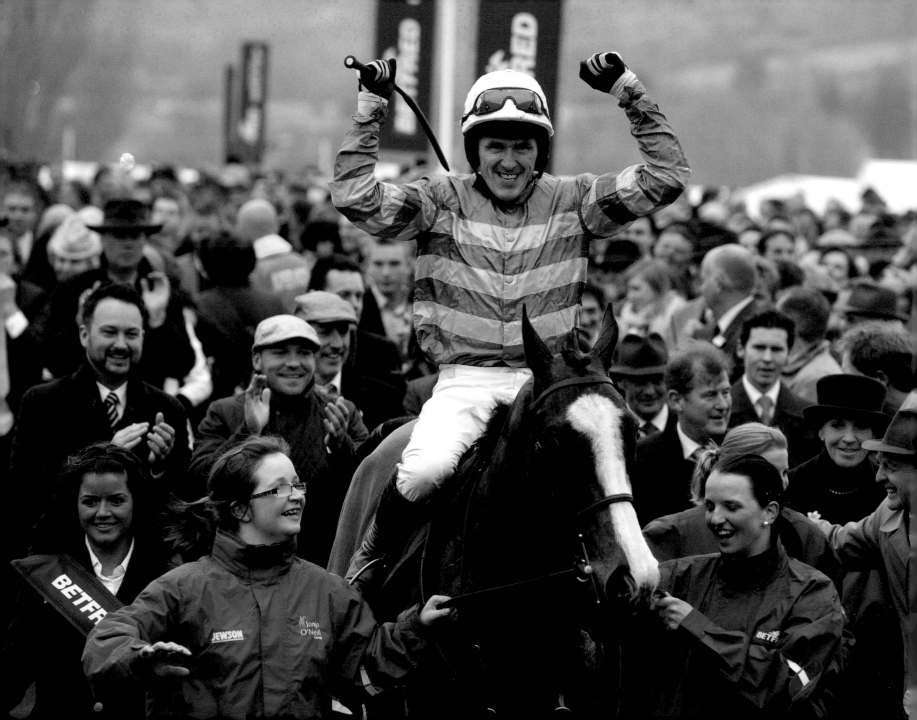

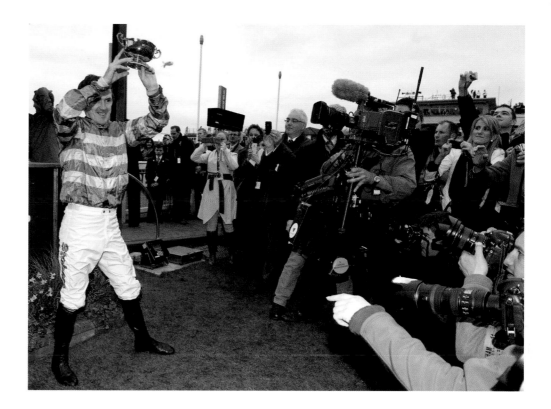

### GOLD CUP GLORY

Cheltenham, 16 March 2012: this is the
Blue Riband of the steeplechasing game.
Pride never feels stronger than this.

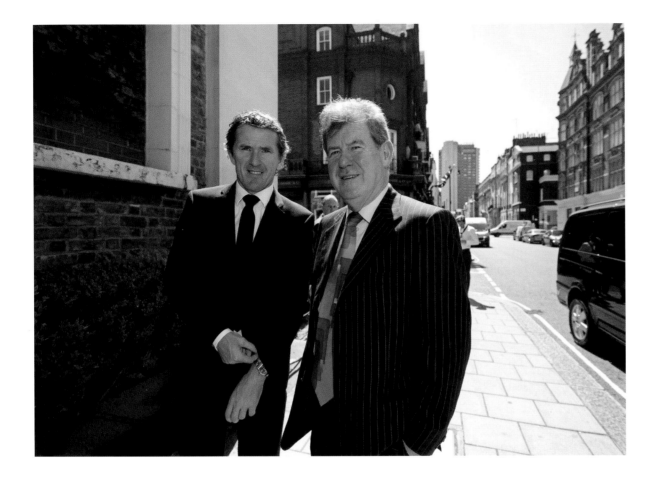

## A MOMENT'S PAUSE

London, Mayfair, 19 July 2013: McCoy
and JP McManus about to go into the
Grosvenor Chapel for the Memorial Service
for David Johnson, owner of Well Chief
and so many other McCoy winners.

## *Opposite* THE NERVOUS NINETIES

Exeter, 4 November 2013: McCoy walks
into the paddock before the three-mile
chase. He was still a handful away from the
4,000-winners target, with a media circus
already in tow.

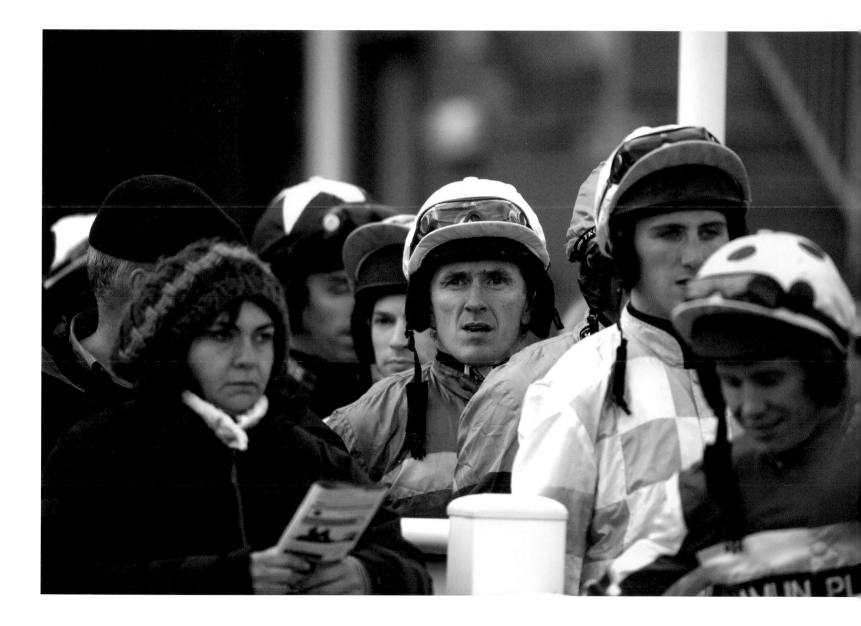

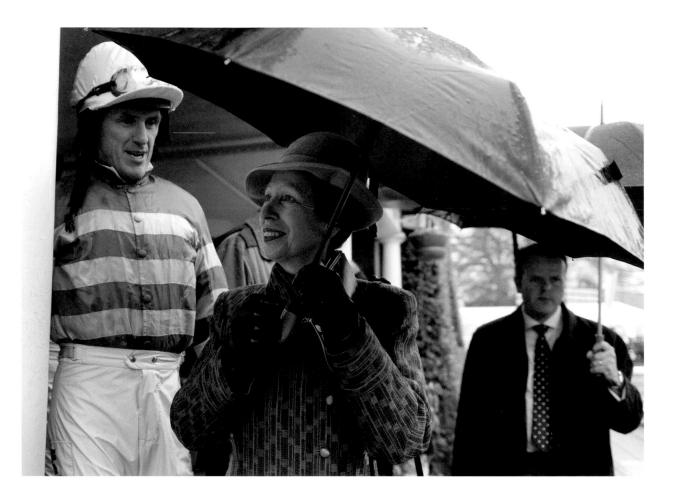

## ROYAL ASSENT

Sandown Park, 8 March 2013: Princess
Anne and McCoy chat on Grand Military
Gold Cup day at Sandown. Is he asking to
borrow the umbrella?

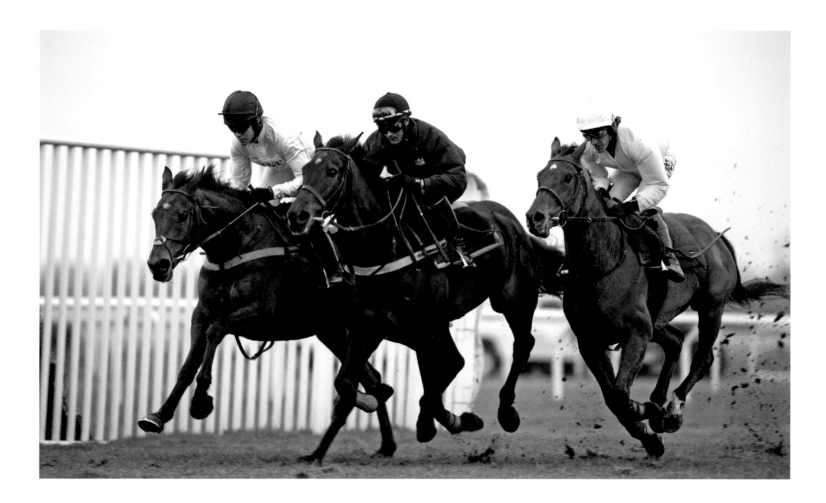

## CHELTENHAM CONTENDERS

Kempton 23 February 2013: Nicky Henderson-trained hopefuls Bobs Worth (Barry Geraghty), Long Run (Nico de Boinville) and Binocular (AP McCoy) work out at Kempton. Bobs Worth won the Gold Cup with Long Run third, but Binocular could only finish fifth in the Champion Hurdle behind Hurricane Fly.

## READY FOR THE CHARGE

Taunton, 19 February 2013: McCoy and the posse at the start of the three-mile hurdle.

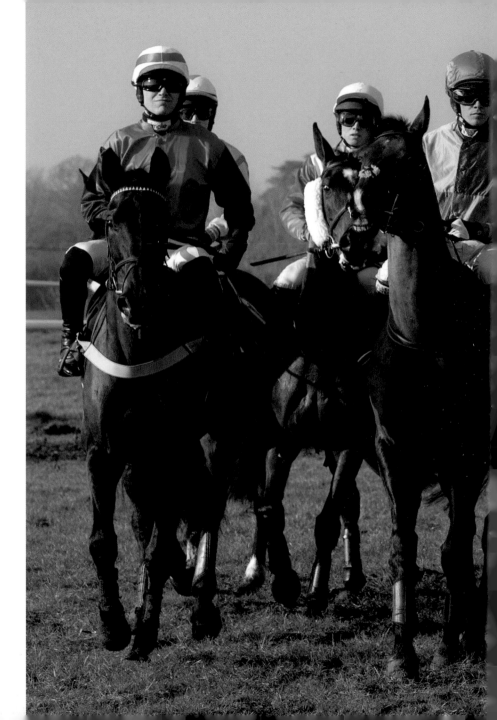

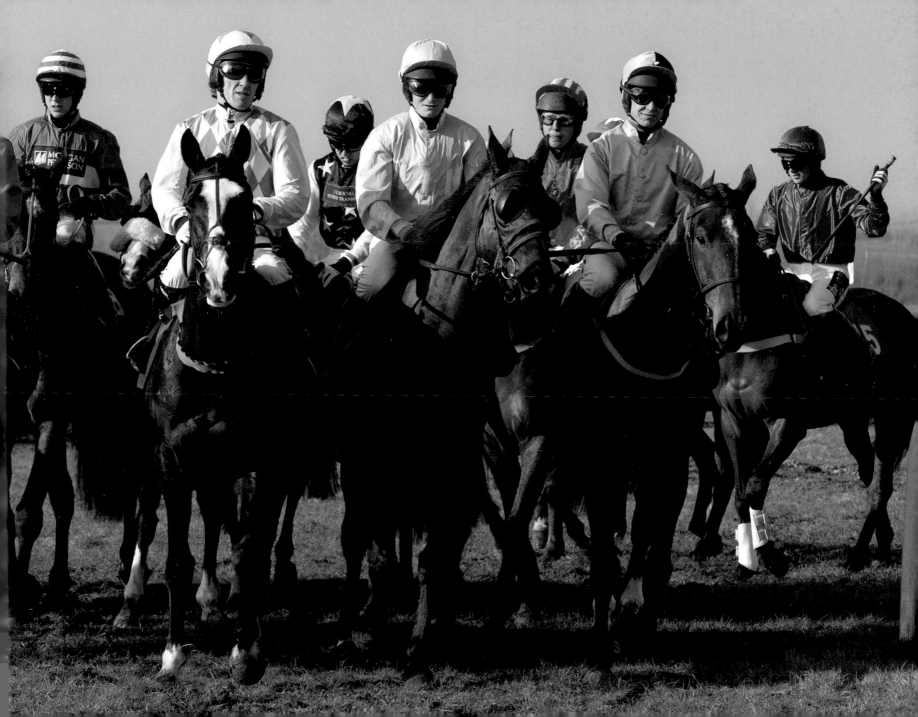

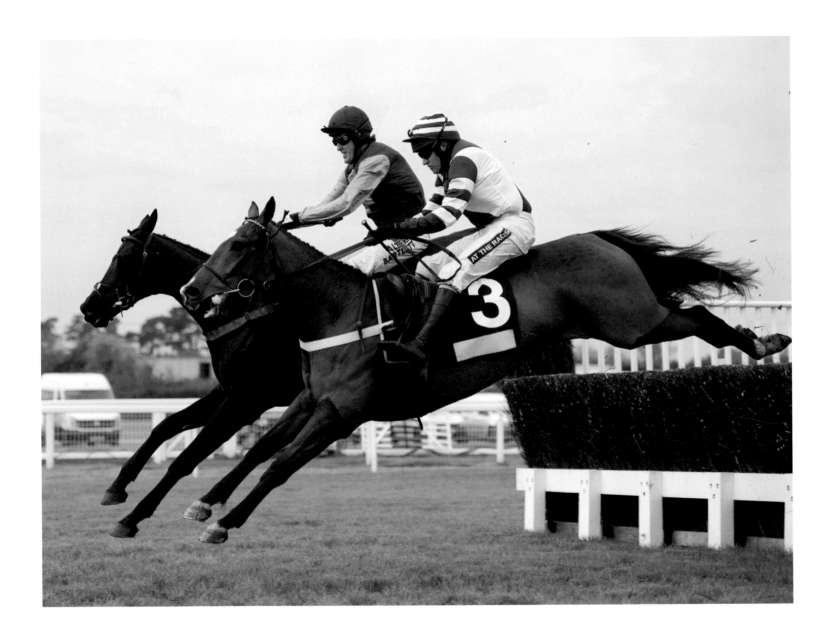

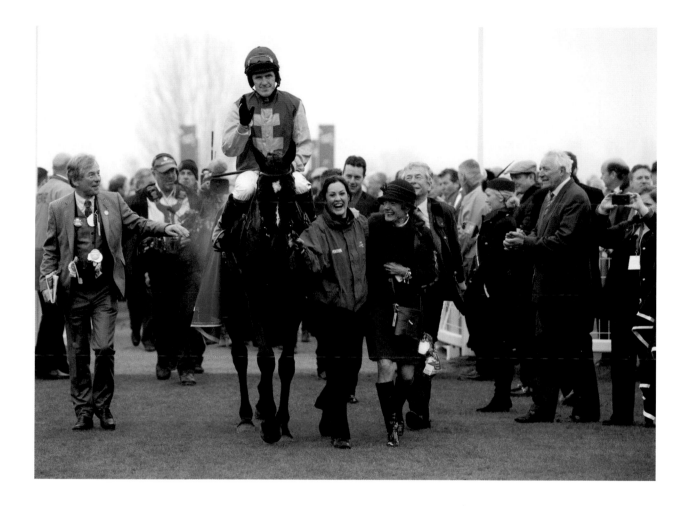

**Opposite FULL FLIGHT**

Cheltenham, 15 November 2013: McCoy on Taquin Du Seuil (*far side*) jumps the second-last alongside Oscar Whisky (Barry Geraghty).

**VICTORY JOY**

Cheltenham, 13 March 2014: McCoy after winning the JLT Novice Chase on Tarquin Du Seuil at the Cheltenham Festival, despite such pain from a fall the day before that he could hardly walk (see next page).

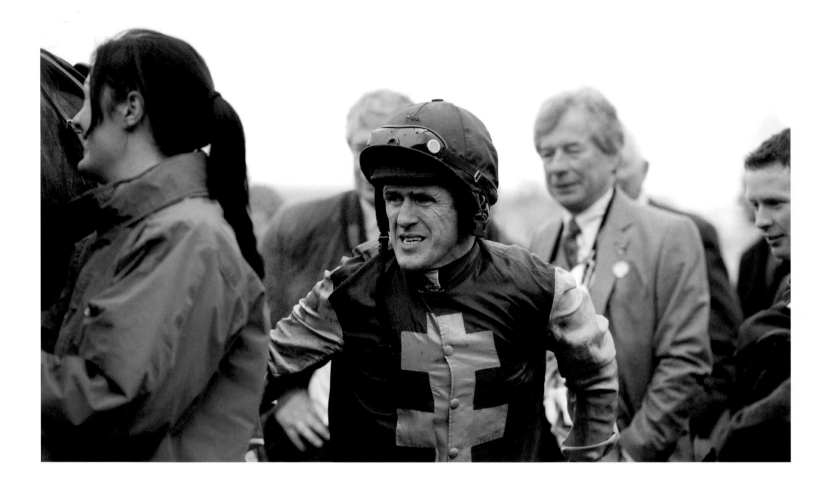

VICTORY HURTS

Cheltenham, 13 March 2014: as McCoy dismounts, the pain kicks in.

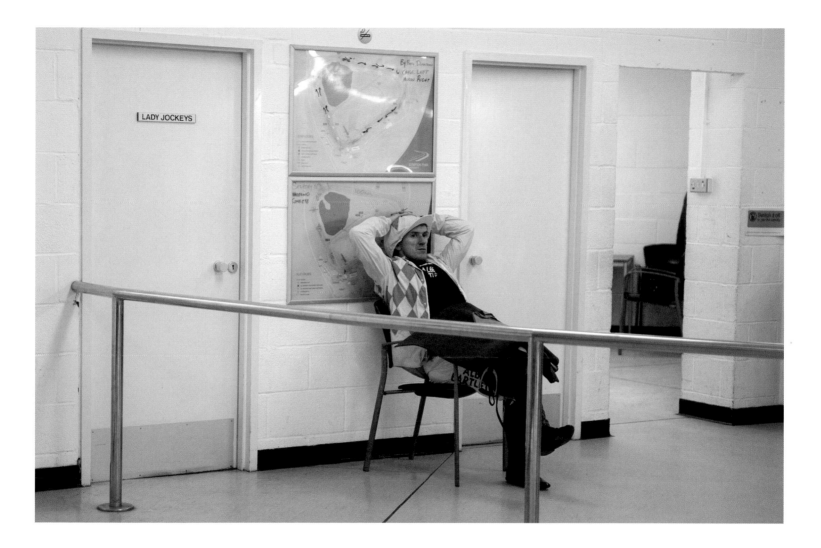

LADY JOCKEYS

TIME OUT

Kempton, 25 January 2013: waiting to ride in the 'bumpers for jumpers' card.

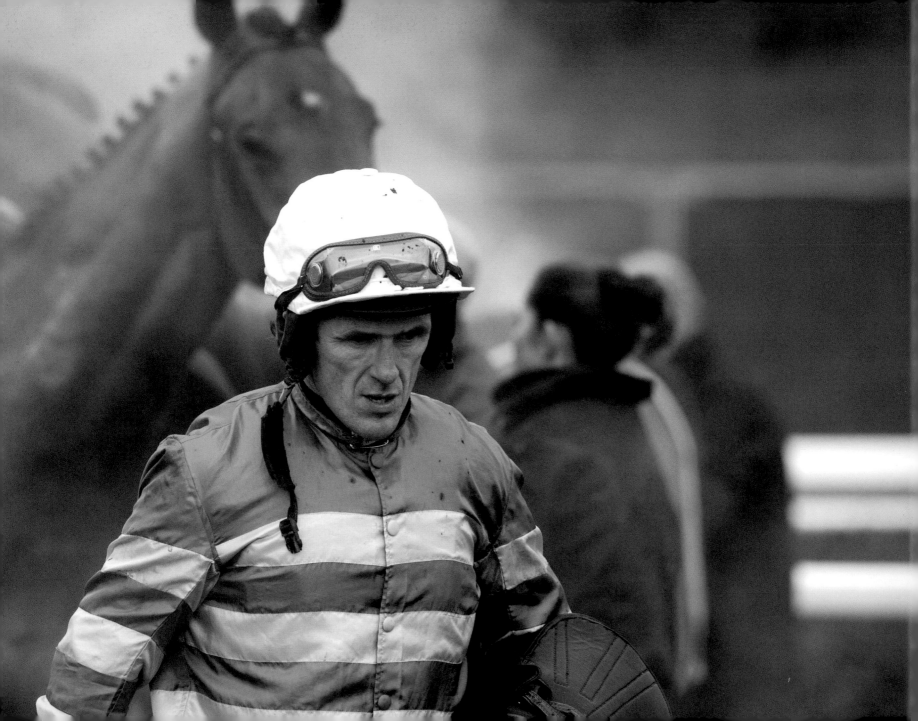

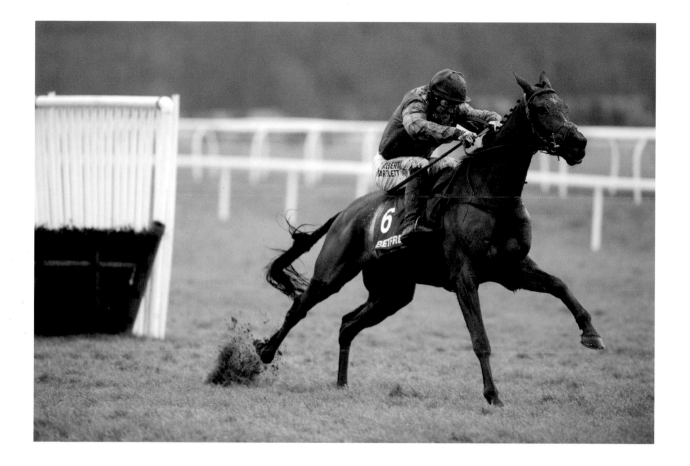

*Opposite* MIDWINTER THOUGHTS

Newbury, 16 January 2013: after finishing only fourth on Colour Squadron in a novice chase in January.

ALL OUT

Newbury, 29 December 2012: keeping up the drive on a slipping Taquin Du Seuil to win the Challow Hurdle.

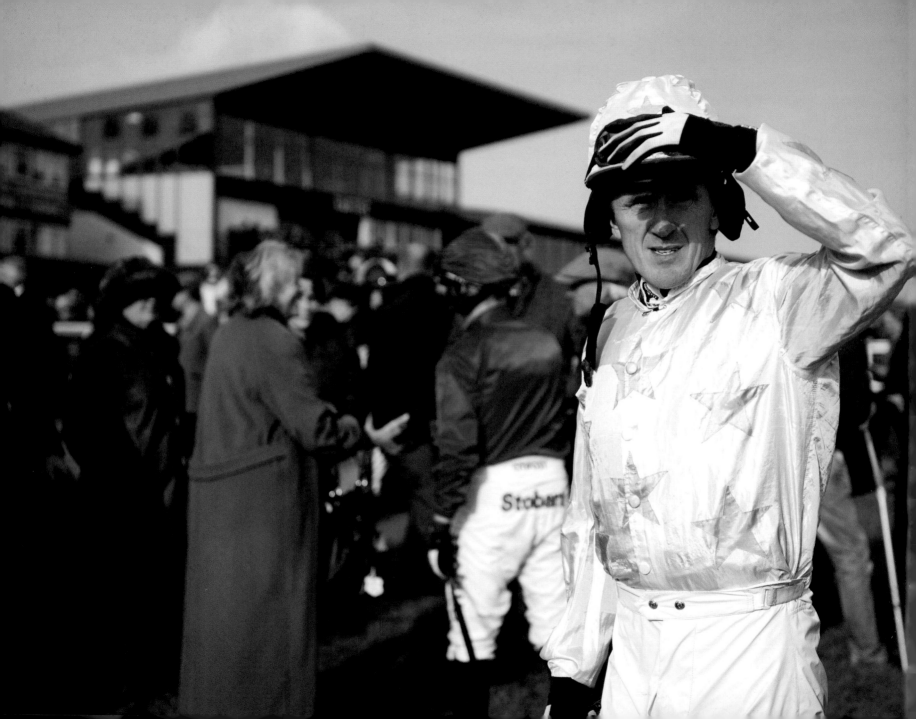

*Left* LOOKING FOR 3,999

Exeter, 5 November 2013: the score was still only 3,998.

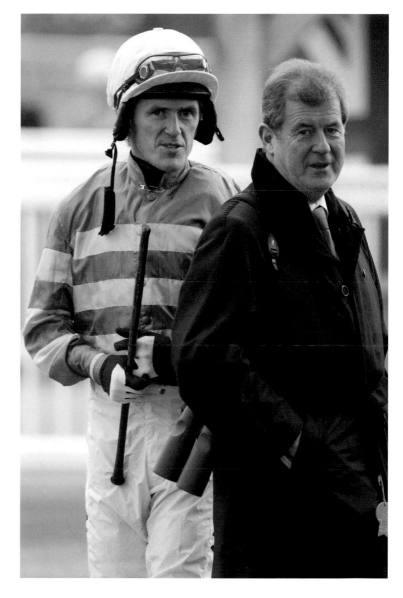

THE STRAIN IS OVER

Plumpton, 18 November 2013: the relaxed faces of McCoy and McManus before the novice hurdle.

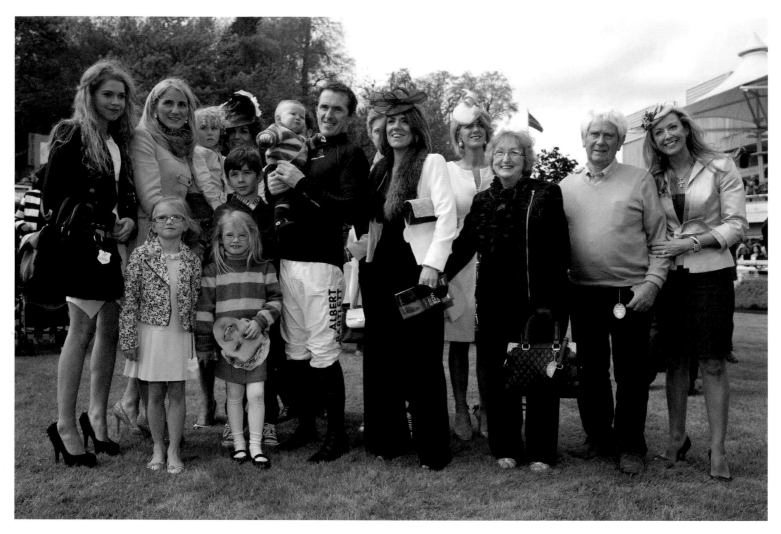

CLAN MCCOY

Sandown Park, 26 April 2014: the whole McCoy family gather to celebrate the presentation of AP's 19th jockeys' championship. Archie Peadar McCoy is in his father's arms.

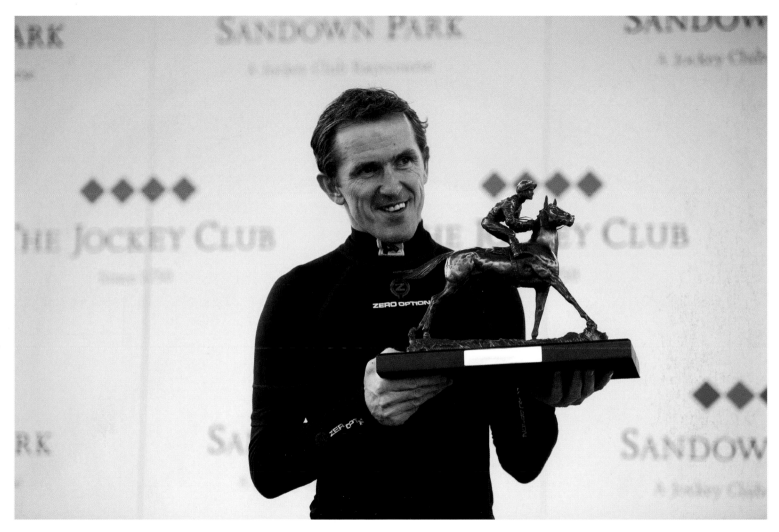

## YOUNG ONES' TURN

Sandown Park, 26 April 2014: presenting the trophy for champion conditional jockey – which he had won back in 1995.

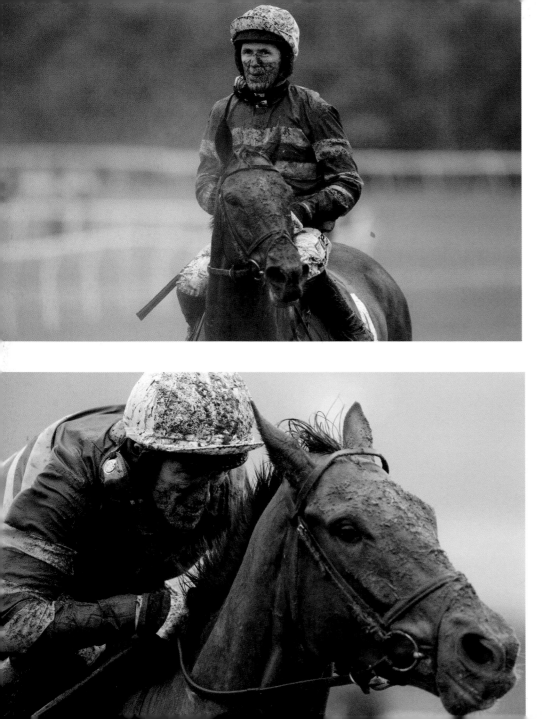

## 3,998 AND STILL COUNTING

Chepstow, 6 November 2013: El Macca finishes unplaced in the maiden hurdle leaving McCoy still two short of 4,000. Next day would be different.

## ON THE BRINK

Towcester, 7 November 2013: in the paddock to ride Mountain Tunes and the 4,000th winner.

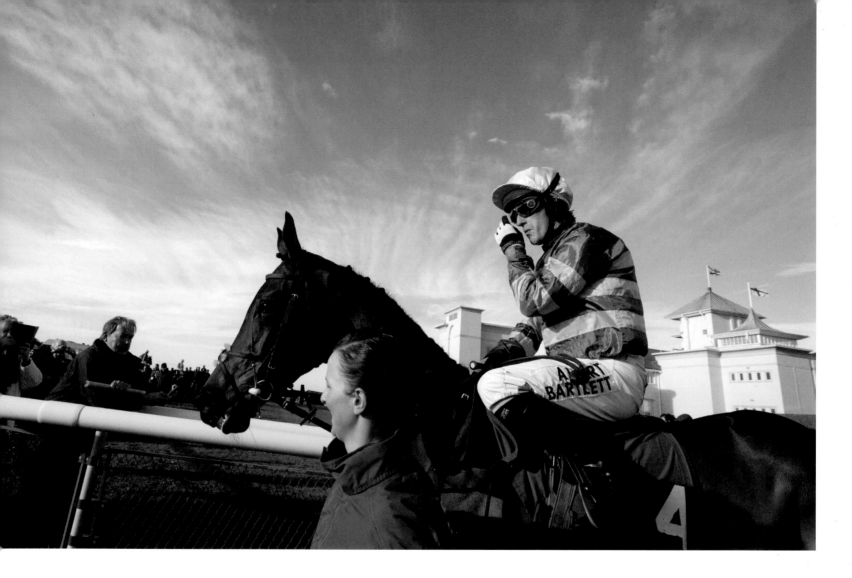

**THE SKY AWAITS**

Towcester, 7 November 2013: going out on to the track.

*Opposite* **HE COULDN'T DO IT, BUT HE DID**

Towcester, 7 November 2013: Mountain Tunes was five lengths adrift and struggling before the last hurdle – but McCoy had other ideas . . .

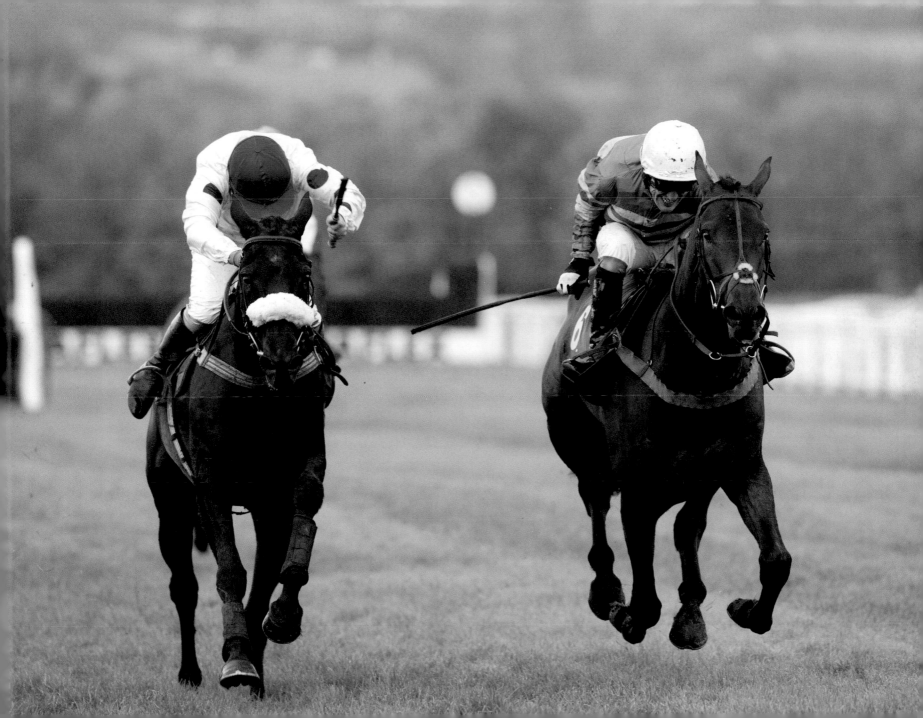

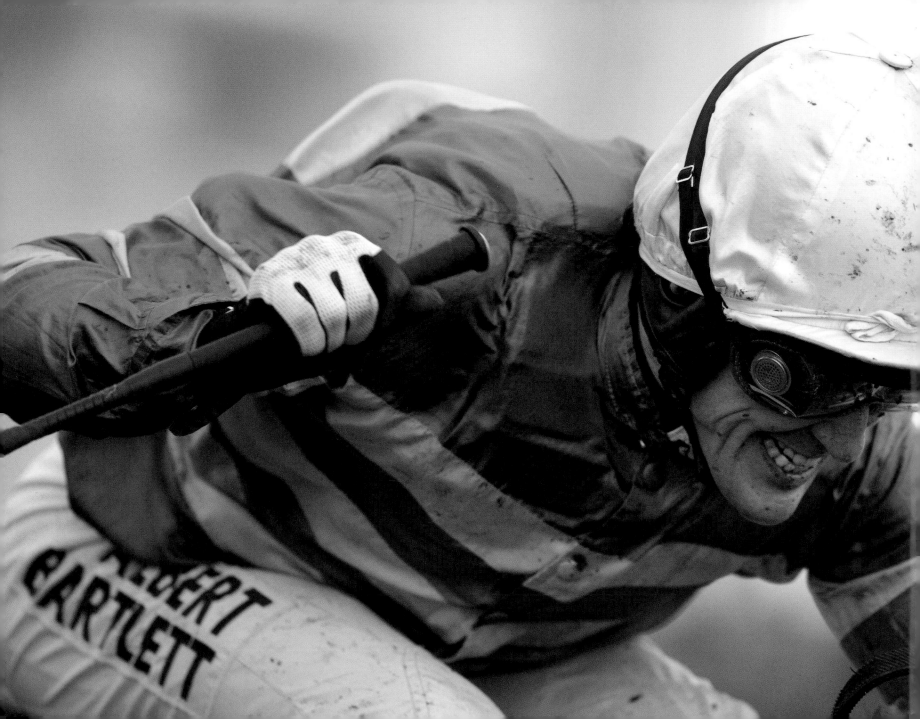

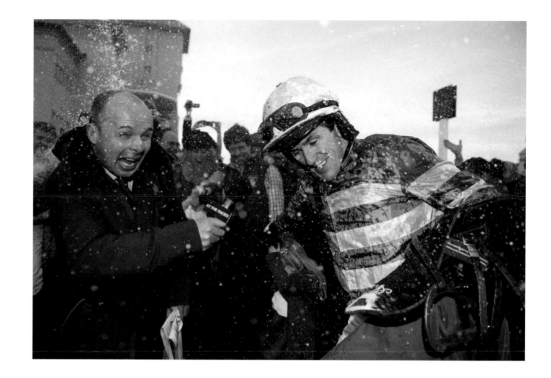

## BUBBLES DON'T HURT

Towcester, 7 November 2013:
Luke Harvey has his cork popped as
he does the 4,000-winner interview.

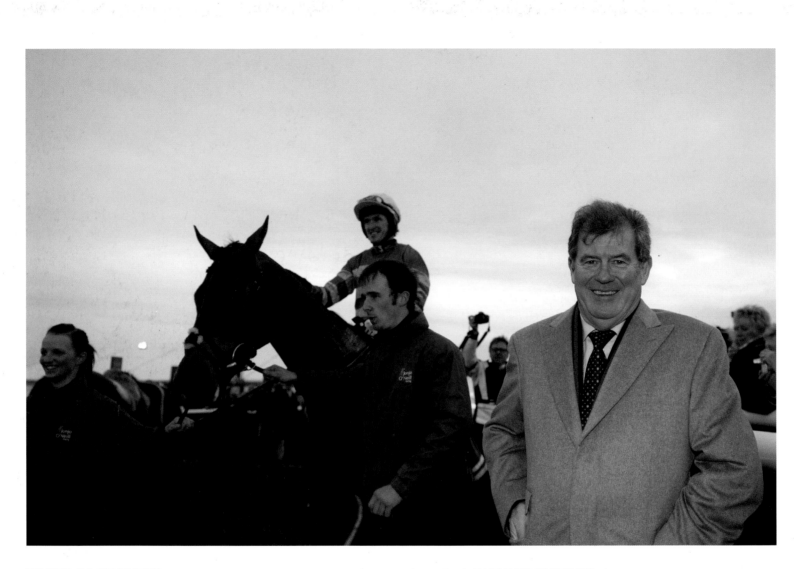

**PROUD TO BE THERE**

Towcester, 7 November 2013: JP shares AP's big day.

*Opposite* A CUP FOR HISTORY

Towcester, 7 November 2013: Towcester found a special trophy for a special feat.

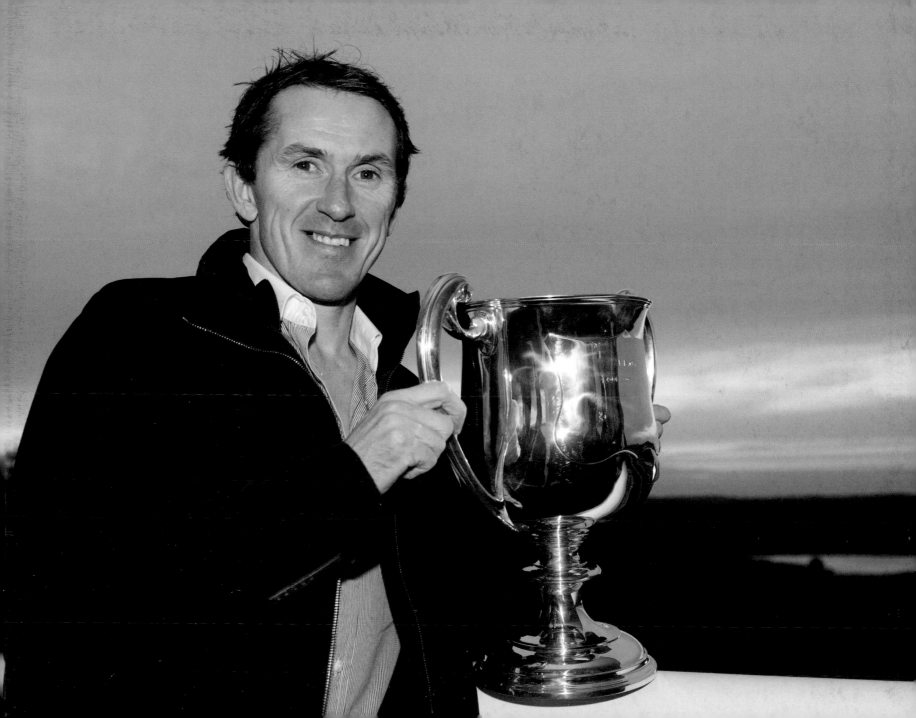

# Acknowlegements

As ever, I am greatly indebted to a number of people for their assistance in the organisation of this book.

In particular I wish to thank my great mentors Brough Scott and legendary sports photographer Chris Smith, for their continued enthusiasm and hard work during the preparation of my third photography book.

For their encouragement and advice, the publishers, James de Wesselow, Julian Brown and the wonderful Liz Ampairee.

Special thanks to Alan Byrne, the CEO of *Racing Post* for his continued support and guidance.

I am also grateful to my diligent editors Bruce Millington and David Cramphorn who give me the opportunities in producing images published in the *Racing Post*.

Not forgetting page designers John Schwartz and Jay Vincent for their inspirational work. Finally, to my lovely picture desk colleagues Nigel Jones, Stef Searle and Jenny Robertshaw for their brilliant work in colour correcting images.

Copyright © Edward Whitaker 2014

The right of Edward Whitaker to be identified as the author of this work has been asserted by him in accordance with the Copyright, Designs and Patents Act 1988.

First published in Great Britain in 2014
By Racing Post Books
27 Kingfisher Court, Hambridge Road,
Newbury, Berkshire RG14 5SJ

10 9 8 7 6 5 4 3 2 1

A catalogue record for this book is available from the British Library.

ISBN 978-1-909471-70-2

Cover designed by Jay Vincent
Text designed by J Schwartz & Co.

Printed and bound in the Czech Republic by Finidr

Every effort has been made to fulfil requirements with regard to copyright material. The author and publisher will be glad to rectify any omissions at the earliest opportunity.

www.racingpost.com/shop